Anton
Henning
Sandpipers,
Lizards
& History

Haunch
of Venison
2005

Dedicated to my father
Robert F. Henning

Out on his own
Richard Cork

In the final year of the twentieth century, a bearded and bespectacled man rows out into the sea. The water's immensity accentuates his isolation. He has four sturdy oars, and they seem capable of ensuring his eventual return to land. But he seems in no hurry to go back, and appears utterly alone. The painting's title does not reveal whether Anton Henning intended this large, panoramic canvas as a self-portrait. He called it, tantalisingly, Mit Gott. But the solitary rower certainly bears a resemblance to Anton Henning himself, and the entire image offers an arresting introduction to his work as a whole. The overall mood is intensely ambiguous: the man could either be savouring a profound sense of spiritual peace, or suffering from a paralysing awareness of nature's vastness. One thing, however, is clear. Anton Henning is out on his own, and thrives on a heretical readiness to defy the rigid boundaries confining so many artists in our time.

This refusal to remain trapped inside a single style or medium becomes dramatically apparent from the moment we enter Sandpipers, Lizards & History. The very first painting, Interieur No. 292, positioned near us on the right wall of the ground-floor gallery at Haunch of Venison, ambushes our vision with swirling yellow and brown stripes. They threaten to suck the viewer in, like an Art Nouveau whirlpool. It is as if the calmness of the sea in Anton Henning's Mit Gott canvas had suddenly been galvanised by a storm, transforming the frenzied liquid into a source of acute danger. The additional loops of dark and pale green undulating across its surface strengthen the air of menace. They seem to hover on the water, ready to ensnare anyone who moves in for a closer look.

On the wall in front of us, by contrast, the mood could not be more sensuous. In Pin-up No. 94 (Venus von Binenwalde), a full-breasted woman, half-immersed in water at its most placid, smiles as she moves forward with chin up and eyes closed, granting us an uninterrupted view of her body. Her wet hair suggests that she has just emerged, Venus-like, from the sea. Her naked body is painted with spontaneous aplomb, by an artist who clearly relishes the pleasures of the flesh. The entire canvas issues a pictorial invitation to embrace hedonism. The woman may well be enjoying the kind of beach culture celebrated in one of the videos, Les Baigneuses, installed beneath the stairs. In it, the camera roams across the sand, past cars, bicycles, tents and wind-shields, all placed there by people who have made this wide, welcoming beach their own. Adults in swimwear recline on deckchairs while children play nearby, and sometimes we glimpse the sea glinting in the summer sun beyond. The mood of holiday pleasure is further enhanced by the piano music Anton Henning composed specially for the video. Its marine lyricism is akin to Debussy, and yet the same music also accompanies very different images on the neighbouring screen.

Here, in Tisch, München, the artist confronts us with a riot of multi-coloured, curving stripes. Far from adopting the leisurely rhythm so evident on the other screen, the camera closes on the stripes and seems to rush past them in a continuous blur. The hectic speed and visual onslaught are reminiscent of a fairground carousel running out of control. Already, then, Anton Henning is prepared to push us towards extremes of anxiety and delight. So we do not know what to expect on the floor above, and he has already deployed a surprising variety of visual languages as well as moving, without any sign of strain, from paint on canvas to video and music. But at least the sheer unpredictability of the ground-floor room prepares us for the shock administered by the larger space at the top of the stairs. For here, Anton Henning takes possession of the gallery in the same way that the sunbathers occupied the beach. He has transformed the first-floor room so comprehensively that it no longer resembles Haunch of Venison at all.

We enter a radically different world, and even the most functional aspects

of this interior take on a strange new identity. The red fire alarm box catches our attention first, inscribed with the words 'Break Glass Press Here'. In such a context, the instruction seems oddly appropriate. For Anton Henning himself breaks free from the convention of hanging paintings simply on bare white walls. He encloses the fire alarm in a rectangle of black and white paint, flatly applied. In a similar way, he frames the nearby light-switches in strips of green, orange and ochre. Predominantly pale and refreshingly bright, these colours are marshalled with a geometric rigour worthy of Mondrian. And they are applied to all the walls, so that Anton Henning ends up surrounding us with a form of painted architecture.

It decisively affects how we look at the seven highly diverse canvases on display here. And Anton Henning exerts more control over our response by devising the lights for the room as well. The existing tall window has been frosted over with buttermilk, so that the sun's impact is greatly reduced and we cannot see distracting views of the courtyard beyond. Seven blocks, projecting from the walls at different heights, provide their own artificial illumination for the paintings hung directly below them. Nor does Anton Henning stop there. He has also designed furniture for the room: a simple, minimal sofa and two chairs, all containing pale, plump cushions inside generously proportioned wooden cases. Most modern galleries are spartan, refusing to provide visitors with comfortable places where they can sit and meditate. Here, on the other hand, we are able to view the entire environment at our ease.

Even so, Anton Henning does not allow us to feel reassured for long. The top of the only table in the room turns out to be alive with the same swirling, hot-coloured images as the fast-moving video displayed on the floor below. Our old feelings of disorientation return, and they are not eradicated by the mêlée of diverse idioms employed in Anton Henning's canvases. Interieur No. 238, the first one to confront us, just beyond the light switches, appears indecipherable at first. We find ourselves gazing at a hailstorm of paint particles, thickly applied in a seemingly impulsive manner far removed from the calm, orderly flatness of the paint on the wall behind. It looks, initially, like pointillism gone crazy. But then we realise that the outlines of a room with furniture and pictures can be detected within the apparent blizzard of pigment. This interior is confusingly similar to the space we already inhabit, yet the non-illusionistic paint handling prevents us from imagining that we could ever step into the empty room and become part of it.

No sooner have our eyes become accustomed to the heavily encrusted brushwork than Anton Henning insists, once again, that we adjust to another way of seeing. In Spiel No. 2, there is no difficulty involved in identifying the subject. A fair-haired mother and her equally blond child bend over a calf and touch it with

affection. They appear to be playing a game, perhaps encouraging the animal to sip the sea-water at its feet. Judging by the nakedness of the figures and their tanned skin, they may well belong to a family group on the same beach as before. There is no definite way of telling, but the mood is untroubled. Only at the base of the canvas is the smoothness of water replaced by a rapidly brushed circular form. It seems to have escaped from the whirlpool painting on the ground floor, and hints at a greater degree of turbulence. But for the most part, this straight-forward and vigorously executed painting could easily be based on an affectionate snapshot, taken perhaps by the figures' devoted husband and father.

The respite does not last long. Next to this relaxed family painting hangs Blumenstilleben No. 185, a far more formal, almost frieze-like image of three female nudes dancing outdoors. Any speculation that they might occupy a familiar stretch of beach is quickly dispelled. Wild grass grows in a tangle around their feet, and the bare hills beyond fade into an immense expanse of emptiness. Only clouds can be detected here, lit by the glow of a fast-fading sun. Pitched against its colours, the women seem little more than fleeting silhouettes. Their nakedness and interlinked hands stir memories of dancing figures by Matisse, and yet Anton Henning's women lack the dithyrambic energy of their counterparts in Matisse's great 1909 canvas. There are hints, too, of nineteenth-century Salon canvases, still fundamentally indebted to classical precedent.

Anton Henning is very aware of the art of the past. As the title of this exhibition implies, he feeds off history at many levels. And these dancers are freighted with references to tradition. At the same time, though, they seem strangely melancholy. They could even be performing a dance of death on a precipice edge, and Anton Henning reinforces this unease by hanging the canvas vertically so that the figures appear to tumble down its surface. Above all, he subverts the dance even more alarmingly by

introducing some forms suggestive of flowers and leaves. They curl across the women, partially obliterating their bodies and threatening, somehow, to trap them in a predatory embrace.

It is a relief, after such an unsettling encounter, to turn to Pin-up No. 96 (Ariadne), the painting of another naked woman. Rather than dancing in a rural void, she sprawls langorously on a yellow towel or an expanse of sand. The nude submits her already darkened skin to the impact of the sun's rays or maybe a tanning lamp. We do not know, and Anton Henning undoubtedly wants questions to crowd in our minds as we examine the canvas. Her smile, however, is indisputable. Placing both hands behind her head, so that her armpits are fully exposed, she rejoices in nubile indolence. Only the cucumber slices placed over both eyes suggest that she is bent on protecting her skin. They give her a slightly demonic appearance, and Anton Henning adds to our disquiet by placing her body on a sloping surface. He also insists on making the emptiness beyond as black as the implacable midnight darkness in Caravaggio's most ominous late paintings. The power of the black segment, combined with the freely executed lines meandering round the woman's body, show that Anton Henning is prepared to deploy abstract elements even in his most figurative works. And the other two paintings in this complex first-floor room rely to a much greater extent on abstraction. In one mysterious canvas, Blumenstilleben No. 175, he hints at the existence of a landscape stretching across the lowest reaches. It is disrupted by his obsessive motif, reminiscent at once of a plant or a propellor. The artist himself calls it a Hennling, suggesting that he regards it fondly as an errant child. But the rest of the picture-surface is invaded by a V-shape, thrusting through space in a heraldic sequence of fierce blue, orange and red diagonals. They assert the viability of abstract interventions, even if the painting as a whole has not altogether sundered its links with representational art. Interieur No. 267, the final canvas

in the room pushes us still further away from an identifiable world. Anton Henning's concentration here on colossal discs recalls Robert Delaunay's protracted preoccupation with the same theme. They radiate outwards, spreading their power to the very edges of the wide canvas. Anton Henning's starting-point might conceivably have been rhythmic lines observed in water. But the vehement colours he employs are far more redolent of the sun. The whole work is wildly painted, with a deliberate emphasis on dissonance. It indicates a desire, on the artist's part, to escape from tastefulness. The longer this painting is scrutinised, the more it resembles the imminence of a conflagration in the cosmos.

As we mount more stairs to the even loftier space on the top floor, our eyes are caught by a small green Fire Exit sign framed by the artist's wall-painting. The diagrammatic running figure, combined with the downward-pointing arrow, seems to suggest that visitors can still escape from Anton Henning's world if they wish. But the urge to make further discoveries impels us upwards, past a large painting above our heads alive with an almost delirious swirl of excitable lines and colours. Their agitated vitality is at odds with the flat, geometric and predominantly pale patterns asserted once again on the walls of the entire room. But up here a lofty skylight provides most of the illumination, apart from a single long seat with wrinkled silicone cushions emitting a subtle glow. The artist eradicates the floorboards by covering them in a vast expanse of yellow carpet. It spreads across the space like sand on a particularly inviting beach, and the request to protect it by taking off our shoes increases the mood of holiday informality.

As if to greet us, Anton Henning himself appears in the first painting visible at the top of the stairs. Although clearly a self-portrait, it is called Sandpiper with Beard. On his long walks across the beach, therefore, Anton Henning must see himself as a kind of bird haunting open, wet spaces where the water meets the strand. With

hands resting on hips, the naked middle-aged man seems at one with the natural world around him. He grins, as if to register his delight at being released from the pressures of the painter's studio. And his brushwork summarizes hair, skin, sand and clouds with the same feeling of irrepressible vivacity. The emptiness that surrounded Anton Henning in his earlier painting, of the man rowing a solitary boat, reappears here. But it does not seem to impair his equilibrium now, in this buoyant celebration of well-being.

A similar air of contentment pervades Pin-up No. 95 (Danae), a nearby painting of a blonde woman basking like a lizard on the beach. No cucumber slices protect her eyes from the sun this time. She is the epitome of relaxation, and the pale green sand beneath her burnished flesh could not be smoother. The only sign of strangeness lurks on the horizon, where a puzzling blackness again fills the sky. Night has descended prematurely, and it is alleviated only by the cartoon-like

presence of a disappearing sun. Similar to a late Guston, its jauntiness suggests that Anton Henning cannot resist disrupting the picture's placidity with a hint of mischief.

Lulled by all this sensuous gratification, we are not at all prepared for the impact of the large neighbouring canvas, Interieur No. 249. Without any warning, the tempting world of sea and sand disappears completely. In its place, the severity of the wall-painting's structure is asserted. White lines invade the picture, stamping their clean, orderly authority across its surface. But the pigment within the lines is thick to the point of clotted. The colours are clamorous, and the entire image promotes an oppressive sense of claustrophobia. Moreover, Anton Henning does not deny that an alarming hint of a swastika can be discerned among the lines. The whole painting seems freighted with foreboding, as if the artist were giving vent to his anxiety about world-wide violence and, in particular, the worrying upsurge of

what he describes as 'New Fascism' in his native country.

This aggression bursts out still more forcefully in the next painting, Interieur No. 216. Although far smaller, its black lines thrust outwards with the force of an explosion. They enclose shards of bitter, clangorous colour, and the painter's harsh brushmarks reflect this discord by refusing to beguile the viewer with seductive sensations of any kind. By hanging this angry little image next to a grand and openly hedonistic beach scene, Anton Henning dramatises the spirit of deliberate contradiction running through the whole show. He regards life itself as a contradictory set of experiences, and is unafraid to explore utterly polarised emotions on the same wall. Fascinated by the power of antonyms, Anton Henning takes great risks by hanging such disparate images side by side. But he is prepared to make himself vulnerable in this way. After all, it reflects the full complexity of human experience, and Anton Henning is stimulated by the challenge

involved in trying to encompass the bewildering totality of life.

In Strandfahrt No. 5, the breadth of the beach we first encountered in the ground-floor video is depicted, now, in a suitably panoramic canvas. By far the largest painting on show, it also includes sea, sky and people to a greater extent than the video piece. A few cars are visible, most notably a vehicle on the right whose number-plate has been turned into a resting-place for the artist's signature and the painting's date: 'AH 2005'. The other cars, however, are placed further away and seem to be disintegrating in sunlight by the water's edge. They lack the solidity of the man wearing a snorkel, who appears to be painting at an easel. And everyone else ignores him, preferring instead to give themselves over to the familiar pleasures of sunbathing. While a distant flag flutters in the summer breeze, families congregate in groups on the sand.

On the left, though, Anton Henning provides a counterbalance to his signature on the other side of the canvas by portraying himself twice. He feels thoroughly at home here, for this is a beach on a Danish island where his family has taken holidays for many years. The more substantial of the two self-portraits shows him standing in a pose similar to Sandpiper with Beard. But this time he gazes downwards, directing a parental gaze at the child below him. They seem almost fused, and the artist may well be expressing the closeness of their relationship. In the other self-portrait, by contrast, he sits alone in a deckchair clasping a cigar and accompanied by a drink lodged in the sand beside him. Like the sandpiper, he stares straight out of the picture in our direction, shielding his eyes with a hand. But the sunglasses he is wearing make his gaze appear curiously blank.

So we become aware, even in this convivial scene, of the fundamental enigma of existence. And the first painting on the final wall serves only to increase the air of mystery. Dominated by the geometric lines of the wall-painting behind, it is called Interieur No. 275. We are entitled to see it as a highly abstracted vision of a room with furniture and pictures, a theme as important to Anton Henning as it was to Matisse when he painted The Red Studio back in 1911. The dark brown running along the centre of Anton Henning's painting is, however, far less exuberant than Matisse, with his consistent love of 'luxe, calme et volupté'.

Ambiguity remains Anton Henning's forte to the end, and, Pin-up No. 97 (Lupa), the last substantial painting on the wall is no exception. At first glance, it appears straightforwardly sensual. A nude, fair-haired young woman is depicted in profile, with chin resting on hands. Her legs are bunched up, providing a base for her elbows. Although she is sunbathing, and the green sky beyond is notably fresh, the angular structure of her limbs also introduces a note of severity. We cannot see the upper portion of her head. Anton Henning slices it off at the top of the canvas, so that we are unable to tell if her eyes are open or closed. But she still looks resolute, even obstinate, and prepared to hold her ground.

In this respect her defiant pose reflects Anton Henning's own stance, as an openly idiosyncratic artist who shuns conventional notions of stylistic consistency as readily as he opts for a heterogeneous array of media. Moving towards the multi-media ideal of the gesamtkunstwerk, he uses every resource at his disposal in order to arrive at a more wide-ranging and fully articulate vision. Determined not to play safe, Anton Henning nevertheless aims at the stubborn eloquence of the bird who, in Abendlied 21.30 Uhr, the smallest painting on view, stays vigilant on a branch at sunset and continues to sing, even as the light fades away to nothing.

Richard Cork is an art critic, historian, broadcaster and exhibition organiser. His most recent books are four paperbacks of critical writings on modern art, 1970—2000, published by Yale.

## Unbeirrt im Eigensinn
Richard Cork

Im letzten Jahr des zwanzigsten Jahrhunderts rudert ein bärtiger und bebrillter Mann hinaus aufs Meer. Das gewaltige Ausmaß der Wasserfläche unterstreicht seine Isolation. Er hat vier stabile Ruder, die seine Rückkehr an Land sicherzustellen scheinen. Aber es sieht nicht so aus, als habe er es eilig zurückzukehren, und er scheint völlig allein zu sein. Der Titel des Gemäldes, Mit Gott, verrät nicht, ob diese große Panoramaleinwand als Selbstporträt gedacht ist. Doch der einsame Ruderer hat zweifellos Ähnlichkeit mit Anton Henning selbst, und nicht zuletzt bietet das Bild eine faszinierende Einführung in das gesamte Schaffen des Künstlers. Die tragende Stimmung ist überaus mehrdeutig: Der Mann könnte ein tiefes Gefühl spirituellen Friedens genießen. Oder hält er inne, weil er angesichts der unendlichen Größe der Natur überwältigt ist? Eines allerdings wird deutlich: Anton Henning ist allein dort draußen, und er blüht geradezu auf in seiner unbeirrt eigensinnigen Bereitschaft, sich den starren Grenzen, von denen sich so viele Künstler unserer Zeit einschränken lassen, zu widersetzen.

Diese Weigerung, sich von einem einzigen Stil oder Medium gefangennehmen zu lassen, wird von dem Moment an, in dem wir die Ausstellung Sandpipers, Lizards & History betreten, auf dramatische Weise offensichtlich. Interieur No. 292, das erste Bild auf der rechten Wand des Ausstellungsraums im Erdgeschoß der Galerie Haunch of Venison, fesselt unseren Blick mit wirbelnden gelben und braunen Farbbändern, die den Betrachter wie in einen Jugendstil-Whirlpool in sich hineinzusaugen drohen. Es ist, als wäre die ruhige See in Anton Hennings Mit Gott plötzlich von einem Sturm elektrisiert, der das aufgewühlte Wasser in eine Quelle akuter Gefahr verwandelt. Die Windungen in hellem und dunklem Grün, die sich zusätzlich über die ganze Bildfläche schlängeln, verstärken die bedrohliche Atmosphäre. Sie scheinen über dem Wasser zu schweben, bereit, jeden, der sich zur genaueren Betrachtung nähert, zu umschlingen.

Im Vergleich dazu könnte die Stimmung von Pin-up No. 94 (Venus von Binenwalde) kaum sinnlicher sein. Eine vollbusige Frau entsteigt venusgleich einem absolut ruhigem Gewässer. Lächelnd und mit geschlossenen Augen bietet sie uns aufreizend ihren nackten Körper dar, der in leichter Aufsicht gegeben ist. Die spontane Gelassenheit der Malerei zeugt nicht zuletzt von der Fähigkeit des Künstlers, solcherart sinnliche Lüste zu genießen. Die ganze Leinwand kommt einer bildlichen Aufforderung zum Hedonismus gleich. Die Badende könnte durchaus jener Art Strandkultur entstammen, die auf einem der unter der Treppe installierten Videobildschirme zelebriert wird. Ein Kameraschwenk über den Sand, vorbei an Autos, Fahrrädern, Zelten und Strandmuscheln, mit denen die Menschen diesen weiten, einladenden Strand in Besitz genommen haben: Menschen in Badekleidung haben sich auf Liegestühlen ausgestreckt, Kinder spielen, und manchmal erhaschen wir einen Blick auf das in der Sommersonne glitzernde Meer jenseits des Strandlebens. Die Klaviermusik, von Anton Henning eigens für das Video Les Baigneuses komponiert, verstärkt noch die Stimmung freizeitlichen Vergnügens. Ihr maritimer Lyrismus ist dem eines Claude Debussy verwandt, doch untermalt dieselbe Musik auch die sehr anderen Bilder des zweiten, parallel plazierten Bildschirms.

Hier konfrontiert Anton Henning uns mit einer vielfarbigen Explosion geschwungener Streifen. Weit entfernt, vom anderen Bildschirm den betont gemächlichen Rhythmus zu übernehmen, holt die Kamera die Streifen ein und scheint sie in einem alles verwischenden Schwenk zu überholen. Das hektische Tempo und die optische Attacke erinnern an ein außer Kontrolle geratenes Karussell. Anton Henning gönnt uns außergewöhnliche Freuden, und schon im nächsten Augenblick scheut er nicht davor zurück, uns in extreme Ängste zu versetzen. Wir wissen nicht, was uns auf dem darüberliegenden Stockwerk erwartet, hat er doch bereits eine

überraschende Vielfalt visueller Sprachen eingeführt und ist ohne irgendein Anzeichen von Anstrengung von der Farbe auf Leinwand zu Video und Musik übergegangen. Der Umstand, daß schon der Raum im Erdgeschoß nicht im geringsten vorhersehbar ist, bereitet uns zumindest auf den Schock vor, der uns im größeren Raum oben an der Treppe erwartet. Denn hier nimmt Anton Henning den Ausstellungsraum auf die gleiche Weise in Besitz, wie die Sonnenbadenden es mit dem Strand getan haben. Er hat den Raum so vollständig umgewandelt, daß er keinerlei Ähnlichkeit mit dem ursprünglichen Galerieraum von Haunch of Venison mehr hat. Wir betreten eine radikal veränderte Welt, und selbst die funktionalsten Aspekte dieses Raumes erhalten eine merkwürdige neue Identität. Als erstes erregt der rote Feuermelder mit der Aufschrift »Break Glass Press Here« unsere Aufmerksamkeit. In einem solchen Kontext erscheint diese Anweisung seltsam angebracht. Denn der Künstler selbst befreit sich von der

Konvention, Gemälde einfach an nackte weiße Wände zu hängen. Er faßt den Feuermelder mit einem Rechteck aus flach aufgetragener schwarzer und weißer Farbe ein, wie er auf ähnliche Weise die benachbarten Lichtschalter mit Streifen in Grün, Orange und Ocker umrahmt. Ja die ganzen Wände des Galerieraums sind in überwiegend erfrischend hellen Farben bemalt, die in ihrer streng geometrischen Komposition zugleich an Piet Mondrian denken lassen.
Dieses Allover in Form gemalter Architektur beeinflußt entscheidend die Art, wie wir die hier präsentierten sieben höchst unterschiedlichen Leinwände betrachten. Und Anton Henning kontrolliert unsere Wahrnehmungsfähigkeit noch weitergehend, indem er auch die Beleuchtung des Raumes plant. Das vorhandene hohe Fenster ist mit Buttermilch mattiert, so daß das einfallende Sonnenlicht gebrochen und gestreut wird und wir nicht durch den Ausblick auf den dahinterliegenden Hof abgelenkt werden. Sieben in verschiedener Höhe aus den Wänden ragende

Lichtquader liefern eine jeweils eigene künstliche Beleuchtung. Doch geht Anton Henning noch weiter. Er hat für den Raum auch die Möbel entworfen: ein einfaches minimalistisches Sofa und zwei Sessel, alle drei großzügig proportionierte Holzkästen mit dicken Polsterauflagen und Kissen in hellem Leder. Sind die meisten zeitgenössischen Ausstellungsräume eher spartanisch und verweigern den Besuchern bequeme Sitzgelegenheiten zum Verweilen, so können wir hier ganz entspannt und äußerst bequem die gesamte Umgebung auf uns wirken lassen.

Gleichwohl wiegt uns Anton Henning nicht sehr lange in diesem Gefühl wohliger Sicherheit. Auf der Oberfläche eines niedrigen Tisches an der Wand wirbeln dieselben aufregenden Farben, die sich schon vor dem Monitor des schnell bewegten Videobildes im Erdgeschoß auf dem Fußboden spiegelten. Unser bereits erfahrenes Gefühl der Desorientierung kehrt zurück, und es wird durch das Gewühl der in Anton Hennings

Leinwänden eingesetzten unterschiedlichen Idiome nicht gemindert. Interieur No. 238 erscheint zunächst als rätselhaftes Bildobjekt. Wir stehen einem dichten Flirren von Farbpartikeln gegenüber, die pastos und in scheinbar impulsivem Auftrag die Leinwand aufwirbeln und damit weit von dem ruhigen und ordentlichen Gleichmaß der Wandbemalung dahinter entfernt sind. Im ersten Moment sieht es aus wie ein verrückt gewordener Pointillismus. Doch dann erkennen wir, daß sich inmitten des augenscheinlichen Schneetreibens aus Pigmenten die Umrisse eines Raumes mit Möbeln und Bildern entdecken lassen. Dieser Innenraum ähnelt auf verwirrende Weise dem Raum, in dem wir uns gerade befinden, doch der nichtillusionistische Umgang mit der Farbe bewahrt uns vor der Vorstellung, jemals diesen leeren Raum betreten und Teil von ihm werden zu können.

Kaum haben sich unsere Augen an den stark pastosen Pinselstrich gewöhnt, besteht der Maler schon wieder darauf, daß wir uns auf eine andere Sehweise einstellen. Dieses Mal gibt es keine Schwierigkeiten, das Sujet zu identifizieren. In Spiel No. 2 beugen sich eine Frau und ein Kind, beide gleich blond, über ein Kalb und streicheln es zärtlich. Das durch den Titel gegebene Spiel scheint darin zu bestehen, das Tier zum Trinken des (Meer-?) Wassers zu verleiten, in dem alle drei knöcheltief stehen. Nacktheit und gebräunte Haut der Figuren lassen sie uns als Mitglieder einer der Familien vom Strandvideo aus dem Erdgeschoß wähnen; jedenfalls scheint die Stimmung ähnlich unbeschwert. Allein an der Unterkante der Leinwand ist die glatte Fläche des Wassers durch eine rasch gesetzte Kreisform unterbrochen. Als wäre dieser einzelne Wirbel aus dem Whirlpoolbild im Erdgeschoß ausgebrochen, um auf eine stärkere, untergründige Turbulenz hinzuweisen. Doch vor allem mutet dieses kraftvoll und unprätentiös ausgeführte Gemälde am ehesten wie ein vom liebenden Ehemann und Vater der Figuren aufgenommener zärtlicher Schnappschuß an.

Die Ruhepause währt nicht lange. Neben diesem provozierend anrührenden Familienbild hängt eine sehr viel formellere, beinahe friesähnliche Tafel, Blumenstilleben No. 185, mit drei im Freien tanzenden weiblichen Akten. Jede Spekulation, die Tanzenden könnten jenen bereits bekannten Strandstreifen in Besitz nehmen, wird rasch zerstreut. Wildgras wächst in wirrem Gestrüpp zu ihren Füßen, und die nackten Hügel hinter ihnen verschwinden in einer unendlichen Leere. Nur vom Glühen einer schnell verblassenden Sonne angestrahlte Wolken sind hier zu erkennen. Vor deren Farben hingeworfen, erscheinen die Frauen als kaum mehr denn flüchtige Silhouetten. Ihre Nacktheit und die einander gereichten Hände wecken Assoziationen an die tanzenden Figuren bei Henri Matisse, und doch fehlt es Anton Hennings Frauen an der dithyrambischen Energie ihrer Gegenstücke in Matisses großartigem Gemälde von 1909. Auch Anspielungen auf klassizistisch orientierte Salonbilder des 19. Jahrhunderts werden erkennbar.

Anton Henning ist sich der Kunst der Vergangenheit überaus bewußt. Wie der Titel dieser Ausstellung impliziert, bedient er sich freimütig auf vielen Ebenen der Geschichte, und gerade diese Tänzerinnen sind mit Bezügen zur Kunstgeschichte nur so befrachtet. Doch merkwürdig melancholisch wirkt dieser Reigen, der auch als eine Art Totentanz am Rande des Abgrunds interpretiert werden kann. Das damit einhergehende Unbehagen wird vom Künstler noch verstärkt, indem er den im Querformat gemalten Tanz dreht und so die Leinwand als Hochformat präsentiert. Wie haltlos geworden scheinen die Tanzenden von der Bildfläche herunterzufallen. Und noch weiter untergräbt Anton Henning die nur vordergründig bukolische Szene und führt einige an rankende Pflanzen erinnernde Formen ein, die sich um die nackten Leiber winden und sie bedrohlich in raubtierhafter Umarmung einzufangen scheinen.

Ein weiterer Akt, Pin-up No. 96 (Ariadne), räkelt sich verführerisch

lächelnd auf einem gelben Handtuch oder im Sand. Der Ort der Szene bleibt unbestimmt: Sonnenbad am Strand oder unter der Höhensonne im Bräunungsstudio – der Künstler verrät es nicht. Um so offensichtlicher ist die Körpersprache mit hinter dem Kopf verschränkten Armen, die die Achselhöhlen entblößen, und wohlig gedrehten Hüften, die die sexuell attraktive Trägheit des Körpers betonen. Nur die Gurkenscheiben auf den Augen weisen darauf hin, daß die Sonnenbadende sich auch der Gefahr durch Bestrahlung bewußt ist. Die so verdeckten Augen verleihen ihr ein leicht dämonisches Aussehen, und Anton Henning steigert unser Unbehagen noch, indem er ihren Körper auf einem Abhang plaziert – auch dies eine Gestalt, die ihren Halt zu verlieren scheint. Außerdem ist die Leere hinter der bühnenartigen Szenerie so schwarz gehalten wie das unerbittliche Scuro in Caravaggios späten Bildern.

Die Kombination aus frei ausgeführten, sich um den Körper der Frau schlängelnden malerischen Linien und der Kraft des schwarzen Farbfeldes zeigt, wie Anton Henning selbst in seinen figurativen Arbeiten auch vollkommen abstrakte Elemente einsetzt. Und die anderen beiden Bilder in diesem komplexen Raum verlegen sich in noch weit stärkerem Ausmaß auf die Abstraktion. In dem mysteriösen Gemälde Blumenstilleben No. 175 ist im unteren Bildbereich eine Landschaft angedeutet. Unterbrochen wird sie durch Anton Hennings gleichsam zwanghaft immer wieder auftauchendes Motiv, das auf den ersten Blick an eine Pflanze oder einen Propeller denken läßt. Der Künstler selbst nennt es »Hennling« und deutet damit an, daß er es liebevoll als ureigenes, wenngleich abtrünniges Kind betrachtet. In die restliche Bildfläche dringt eine V-Form ein, die sich in einer Abfolge grell blauer, orangefarbener und roter Diagonalen durch den Bildraum schiebt. Diese machen das abstrakte Moment geltend, auch wenn das Bild als Ganzes seine Verbindungen zur gegenständlichen Kunst nicht völlig abgebrochen hat.

Die letzte Leinwand in diesem Raum, <u>Interieur No. 267</u>, drängt uns in noch größere Distanz zu einer begrifflich identifizierbaren Welt. Anton Hennings Konzentration auf gewaltige Scheiben in diesem Bild erinnert an Robert Delaunays lang andauernde Beschäftigung mit demselben Thema. Die Scheiben strahlen nach außen und dehnen ihre Kraft bis an die äußersten Ränder der breiten Leinwand aus. Es ist durchaus denkbar, daß Anton Hennings Ausgangspunkt die im Wasser beobachteten rhythmischen Wellenlinien gewesen sind. Doch die kräftigen Farben, die er einsetzt, erinnern weit mehr an das Farbenspektrum des Sonnenlichts. Komposition und Malweise zeugen von großer gestalterischer Vehemenz, der Schwerpunkt ist bewußt auf Dissonanz gelegt. Es zeigt das Bestreben des Künstlers, dem leichthin Eingängigen und Geschmackvollen zu entfliehen. Und je länger man dieses Bild betrachtet, desto mehr werden bildhafte Assoziationen augenfällig, etwa eine Feuersbrunst gewaltigen Ausmaßes…

Im Aufgang zum obersten Stockwerk fällt unser Blick auf ein von der Wandbemalung des Künstlers gerahmtes kleines grünes Schild mit der Aufschrift »Fire Exit«. Die diagrammartige Kombination eines laufenden Männchens mit einem nach unten zeigenden Pfeil scheint anzudeuten, daß die Besucher der Welt Anton Hennings, wenn sie nur wollen, immer noch entkommen können. Doch der Drang, weitere Entdeckungen zu machen, nötigt uns weiter nach oben, vorbei an einer großen Leinwand über unseren Köpfen, auf der es von einem beinahe taumelnden Wirbel nervöser Linien und Farben nur so wimmelt. Die aufgeregte Vitalität von <u>Interieur No. 266</u> stimmt überhaupt nicht mit den flachen geometrischen und farblich überwiegend zurückgenommenen Mustern überein, die auch hier wieder die Wände des gesamten Raumes überziehen. Hier oben liefert ein Oberlicht den größten Teil der Beleuchtung – abgesehen von einer einzelnen langen Sitzbank mit weichen Silikonkissen, die sanft – wie für sich – leuchten. Die

Bodendielen der Galerie überdeckt der Künstler mit einem riesigen gelben Teppich, der sich wie der Sand eines besonders einladenden Strandes im ganzen Raum ausbreitet, und einmal mehr eine ungezwungene Ferienatmosphäre beschwört.

Unausweichlich und wie zur Begrüßung sieht man sich am oberen Treppenabsatz dem Künstler gegenüber. Eindeutig ein Selbstporträt, titelt es dennoch unpersönlich <u>Strandläufer mit Bart</u>. In leichter Untersicht, die Hände in die Hüften gestemmt, scheint der unbekleidete Mann eins zu sein mit der ihn umgebenden Natur. Er grinst, als wolle er seine Freude darüber zum Ausdruck bringen, vom Druck des Malerateliers befreit zu sein. Und sein Pinselstrich faßt Haar, Haut, Sand und Wolken mit demselben Gefühl nicht zu unterdrückender Lebendigkeit zusammen. Die dräuende Leere, die Anton Henning in seinem Bild des einsamen Ruderers umgab, taucht hier wieder auf. Doch jetzt, in diesem heiteren Feiern des Wohlergehens,

scheint sie sein Gleichgewicht nicht zu beeinträchtigen.

Ein ähnlicher Anschein von Zufriedenheit, wenn auch stiller und weniger offensiv, durchzieht das Bild einer blonden Frau mit dem Titel Pin-up No. 95 (Danae). Wieder eine hingebungsvoll Sonnenbadende, die hier jedoch die Augen ungeschützt läßt. Sie wirkt wie der Inbegriff der Entspannung, und der blaßgrüne Sand unter ihrer matt glänzenden Haut könnte nicht weicher sein. Ein vollkommen friedlich sinnlicher Anblick, lauerte nicht eine Merkwürdigkeit am Horizont: Die Nacht scheint vorzeitig hereingebrochen, und skandiert wird sie nur durch die comicartige Darstellung einer phallisch aufragenden beziehungsweise »phallisch sinkenden« Sonne. Ähnlich einem späten Philip Guston deutet diese spielerische Störung darauf hin, daß Anton Henning dem Drang, die Beschaulichkeit des Bildes mit einem Anflug von Unfug zu unterlaufen, nicht widerstehen konnte.

Eingelullt von all diesen sinnlichen Freuden, sind wir auf die Wirkung von Interieur No. 249, der nächsten großen Leinwand, überhaupt nicht vorbereitet. Ohne jede Warnung ist die verführerische Welt von Meer und Sand völlig verschwunden. Statt dessen setzt sich die strenge Struktur der Wandmalerei durch. Die weißen Linien, die bereits die Farbflächen der Wandmalerei unterteilen, dringen in das Bild ein und drängen ihre saubere, ordentliche Autorität der gesamten Bildfläche auf. Doch ist innerhalb der Linien der Farbauftrag auf der Leinwand so dick, daß er Klumpen bildet. Die Farben wirken laut und dissonant, die gesamte Bildstruktur in ihrer Rigorosität bedrückend. Und Anton Henning bestreitet keineswegs die Andeutung eines Hakenkreuzes, die das Liniengerüst bildet. Das Werk scheint befrachtet mit Vorahnungen, als mache der Künstler hier seiner Angst Luft, angesichts der latenten Gewalt und der schleichenden Präsenz dessen, was er als Neofaschismus in seinem Heimatland beschreibt.

Diese Aggression bricht im nächsten Bild, Interieur No. 216,

noch eindringlicher hervor. Obwohl es sehr viel kleiner ist, drängen seine schwarzen Linien mit der Kraft einer Explosion von einem gemeinsamen Zentrum nach außen. Sie umschließen Scherben von bitterer, klirrender Farbe, und Anton Hennings schroffe Pinselstriche spiegeln diesen Mißklang, indem sie sich weigern, den Betrachter mit belanglosen Empfindungen sanfterer Natur zu täuschen. Indem der Künstler dieses zornige kleine Bild neben eine große und unverhüllt hedonistische Strandszene hängt, inszeniert er den Geist bewußter Widersprüchlichkeit, der uns über die gesamte Ausstellung hin begleitet. Er betrachtet das Leben selbst als eine Ansammlung widersprüchlicher Erfahrungen und schreckt nicht davor zurück, extrem gegensätzliche Emotionen auf derselben Wand zu erforschen. Anton Henning geht ein großes Risiko ein, wenn er so grundverschiedene Bilder nebeneinanderhängt. Aber er ist bereit, sich auf diese Weise selbst verletzbar zu machen. Schließlich spiegelt sich darin die ganze Komplexität menschlicher Erfahrung, und Anton Henning empfindet die Herausforderung, die in dem Versuch liegt, die verwirrende Gesamtheit des Lebens zu umschließen, als anregend.

Strandfahrt No. 5 stellt die Breite des Strandes, auf den wir im Video des Erdgeschosses als erstes gestoßen sind, auf einer panoramischen Leinwand dar. Jedoch zeigt dieses in seinen Ausmaßen bei weitem größte Bild in der Ausstellung noch mehr vom Meer, vom Himmel und den das Strandleben genießenden Menschen als die Videoarbeit. Ein paar Autos sind zu sehen, am auffälligsten darunter ein Fahrzeug rechts, dessen Nummernschild zum Rastplatz für die Signatur des Künstlers und des Entstehungsjahres des Gemäldes geworden ist. Die anderen Autos sind weiter entfernt geparkt und scheinen sich am Ufersaum im Sonnenlicht aufzulösen. Ihnen fehlt die Stabilität des Mannes mit dem Schnorchel, der vor einer Staffelei steht und zu malen scheint. Alle anderen ignorieren ihn und ziehen es vor,

sich dem vertrauten Vergnügen des Sonnenbadens hinzugeben. Und während in der Ferne eine Fahne in der Sommerbrise flattert, versammeln sich grüppchenweise Familien im Sand.

Auch der Künstler scheint sich hier durch und durch zu Hause zu fühlen, handelt es sich doch bei diesem Gemälde um das Porträt eines Strandes der kleinen dänischen Insel, auf der seine Familie jahrelang Urlaub gemacht hat. Und wie als Gegengewicht zu seiner Signatur auf der rechten Seite der Leinwand, positioniert Anton Henning links auch zwei Selbstporträts. Das eine zeigt ihn in einer Pose, die der des Strandläufers mit Bart ähnelt. Doch sieht er dieses Mal nach unten und richtet einen väterlichen Blick auf das Kind zu seinen Füßen. Mann und Kind scheinen als Ausdruck einer engen emotionalen Beziehung beinahe miteinander verschmolzen. Im Gegensatz dazu finden wir den Künstler im anderen Selbstporträt als Solitär in einem Liegestuhl, in der Hand eine Zigarre und neben sich im Sand einen Drink. Wie der Strandläufer blickt er direkt aus dem Bild heraus in unsere Richtung, die Augen mit einer Hand gegen die Sonne abgeschirmt. Doch läßt die Sonnenblende seinen Blick merkwürdig leer erscheinen.

So wird uns also selbst in dieser heiteren und unbeschwerten Szene das fundamentale Rätsel des Lebens vor Augen geführt. Und ein weiteres Bild auf der letzten Wand verstärkt noch den Anschein des Mysteriösen. Dieses von den geometrischen Linien der Wandmalerei dahinter beherrschte Gemälde trägt den Titel Interieur No. 275. Wir sind berechtigt, es als die höchst abstrakte Sicht eines Zimmers mit Möbeln und Bildern zu betrachten, ein Thema, das für Anton Henning genauso wichtig ist wie es etwa für Matisse war, als dieser 1911 L'Atelier rouge malte. Doch ist das dunkle Braun, das hier die Mitte dominiert, sehr viel weniger überschwenglich als die leuchtende Farbigkeit bei Matisse mit seiner steten Vorliebe für »Luxe, calme et volupté«.

Mehrdeutigkeit bleibt bis zum Schluß Anton Hennings Stärke, darin stellt auch das letzte Pin-up No. 97 (Lupa) innerhalb der Ausstellung keine Ausnahme dar. Auf den ersten Blick erscheint es freimütig sinnlich. Eine nackte blonde junge Frau, das Kinn auf die Hände gestützt, ist im Profil dargestellt. Ihre Ellbogen ruhen auf den angezogenen Beinen. Obwohl sie ein Sonnenbad nimmt und der grüne Himmel hinter ihr durchaus sommerlich frisch wirkt, verleiht die eckige Anordnung ihrer Gliedmaßen dem Bild eine strenge, beherrschte Note. Das obere Drittel ihres Kopfes ist nicht zu sehen, da es vom Rand der Leinwand beschnitten ist, so daß wir nicht feststellen können, ob ihre Augen geöffnet oder geschlossen sind. Dennoch gewinnt man den Eindruck einer resoluten, ja hartnäckig und entschlossen ihren Platz auf der Leinwand respektive im Leben behauptenden Frau.

In dieser Hinsicht spiegelt ihre herausfordernde Pose Anton Hennings eigene Haltung als offen eigensinniger Künstler, der den Mainstream stilistischer Konsequenz ebenso scheut wie er sich bereitwillig für eine heterogene Reihe künstlerischer Medien ent-scheidet. Auf seinem Weg hin zum Ideal des Multimedia-Gesamtkunst-werks benutzt er jede ihm zur Verfügung stehende Quelle, um zu einer weiterreichenden und komplexeren Sichtweise zu finden. Entschlossen, nicht auf Sicherheit zu spielen, ist sein Ziel gleichwohl die hartnäckige Eloquenz des Vogels, der im kleinformatigen Abendlied 21.30 Uhr wachsam auf einem Ast in der untergehenden Sonne sitzt und selbst, als das Licht ins Nichts entschwindet, nicht aufhört zu singen.

Richard Cork ist Kunstkritiker, Historiker, Rundfunk- und Fernsehmoderator sowie Ausstellungsmacher. Zu seinen Veröffentlichungen gehören vier Publikationen mit Schriften zur modernen Kunst zwischen 1970 und 2000, erschienen in der Yale University Press.

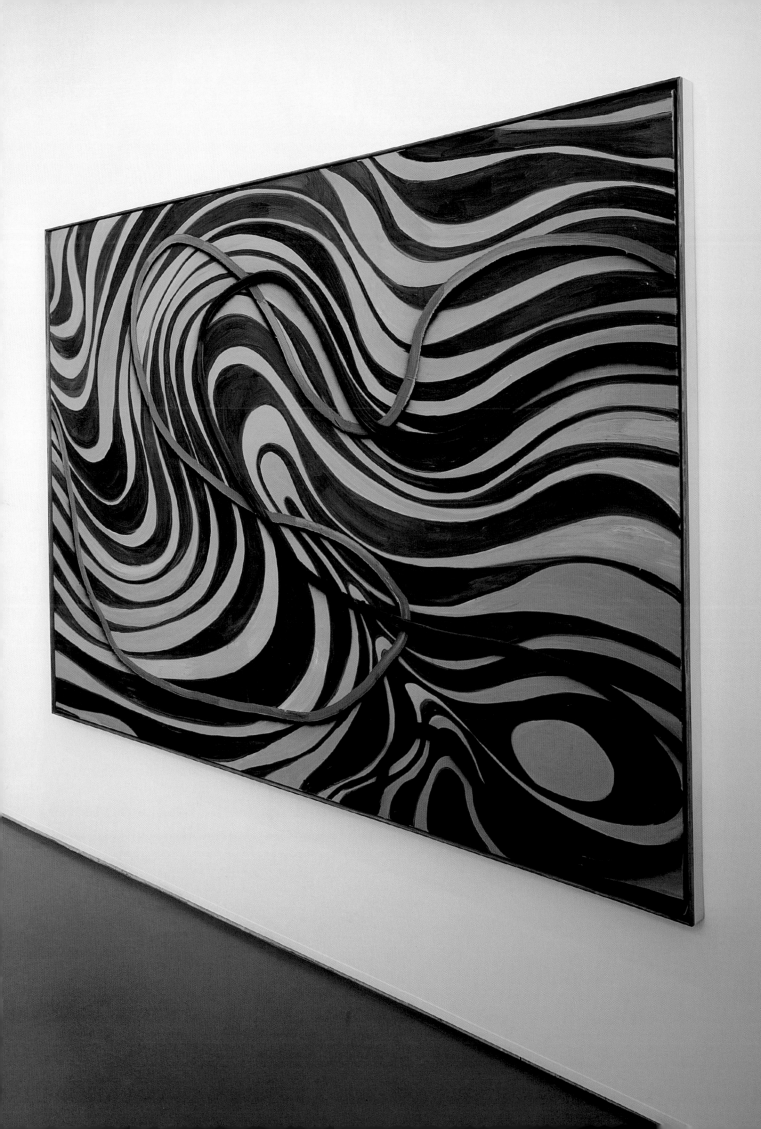

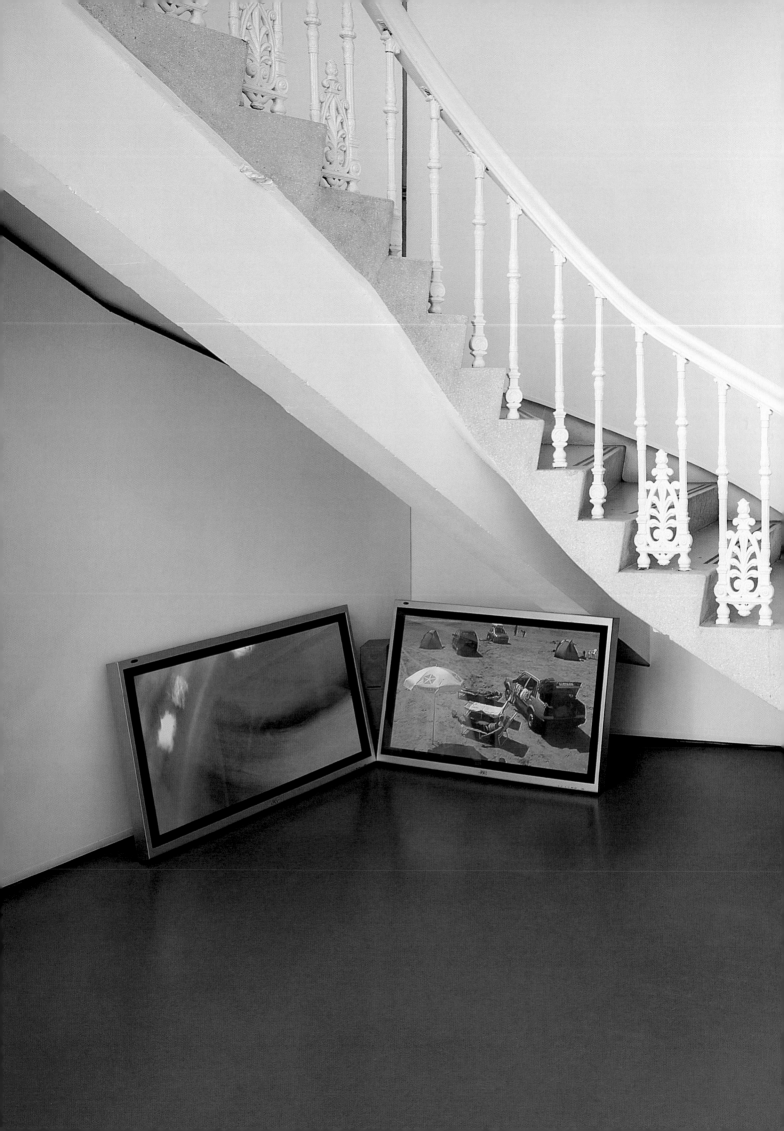

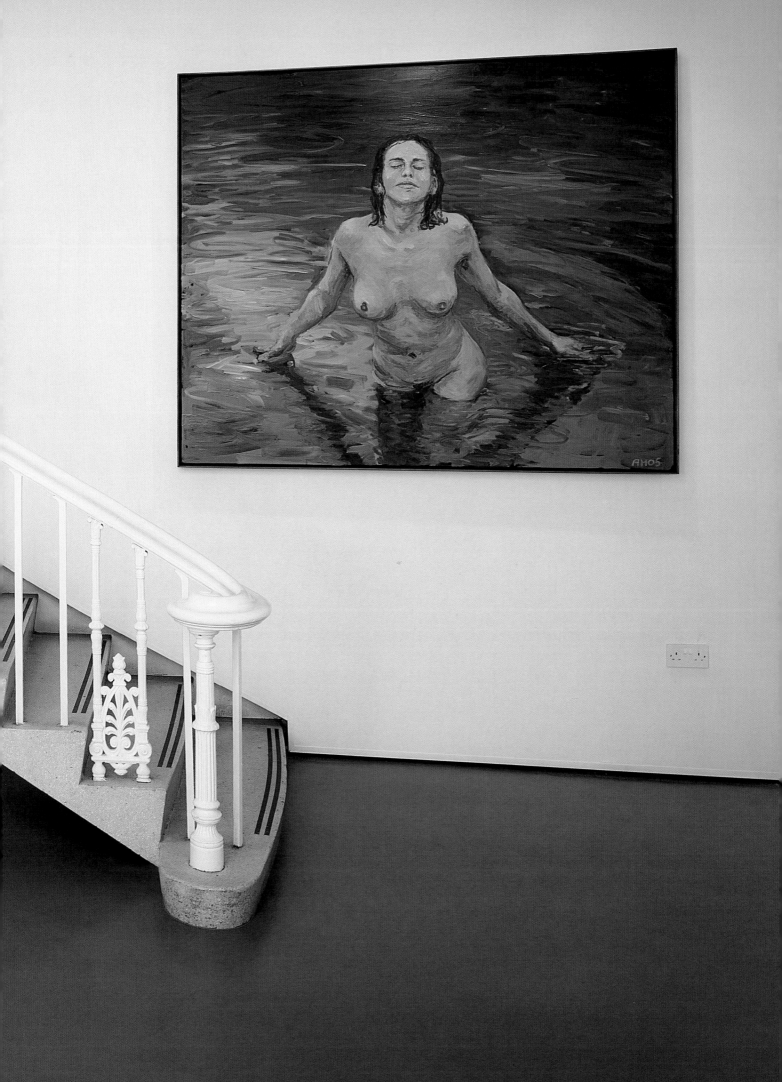

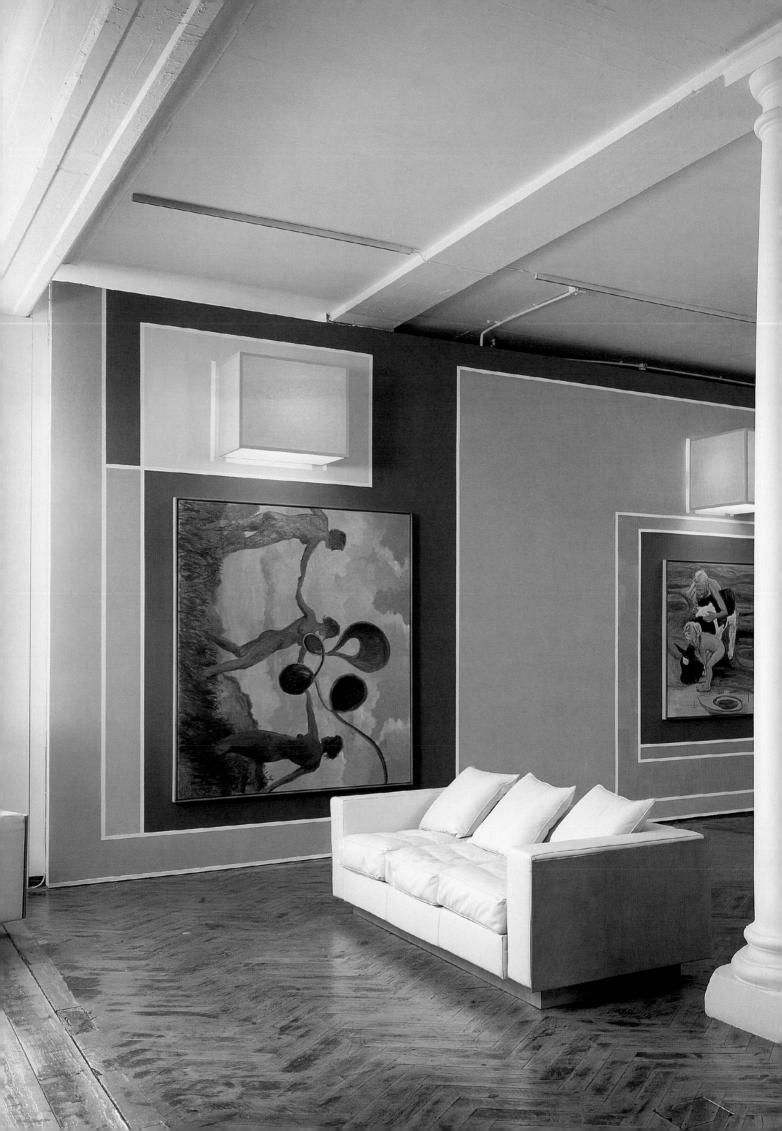

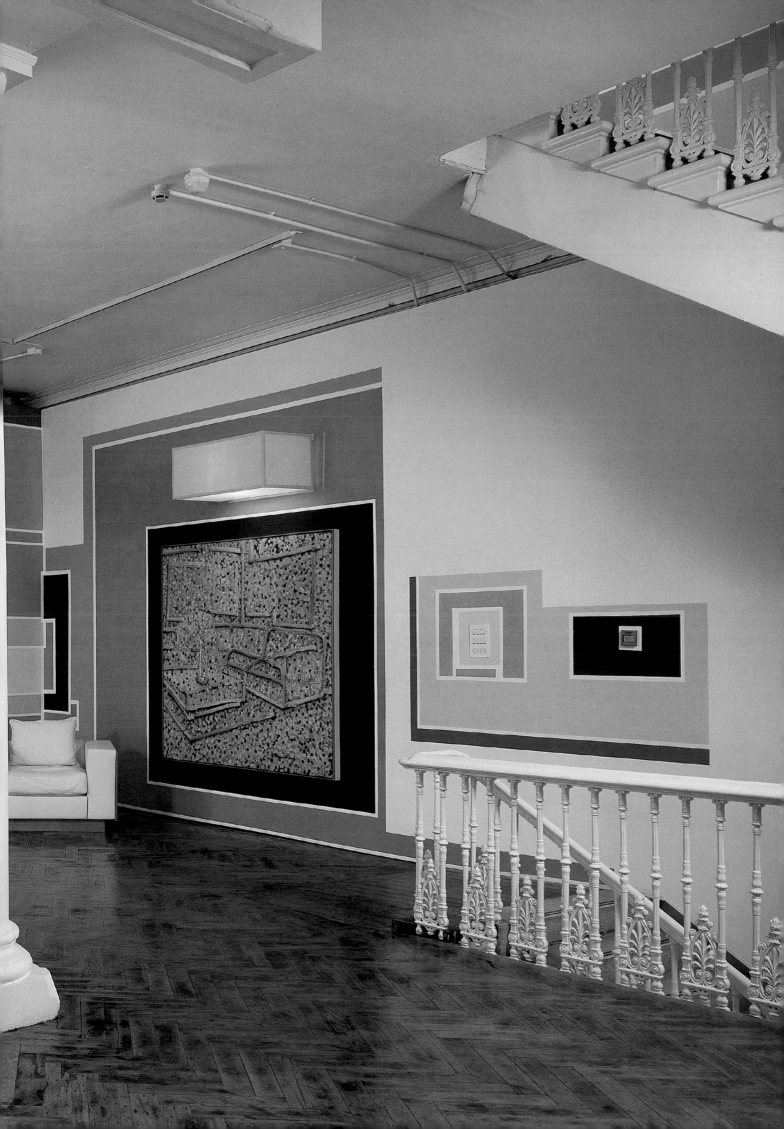

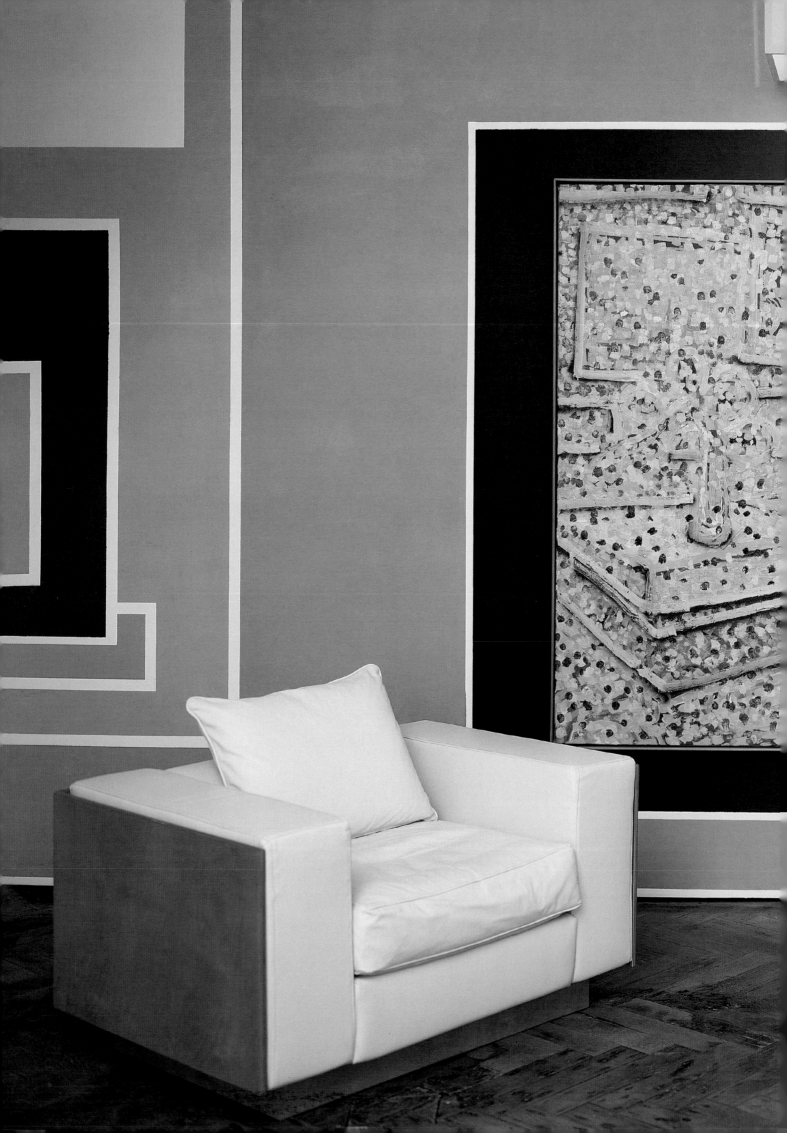

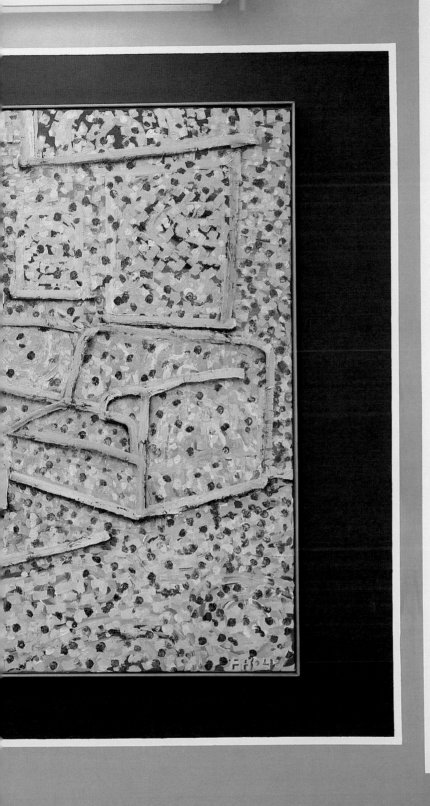

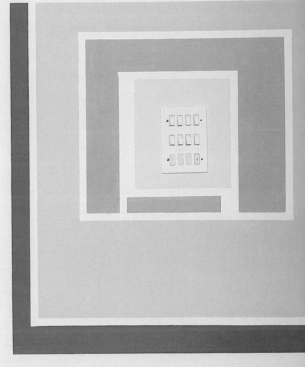

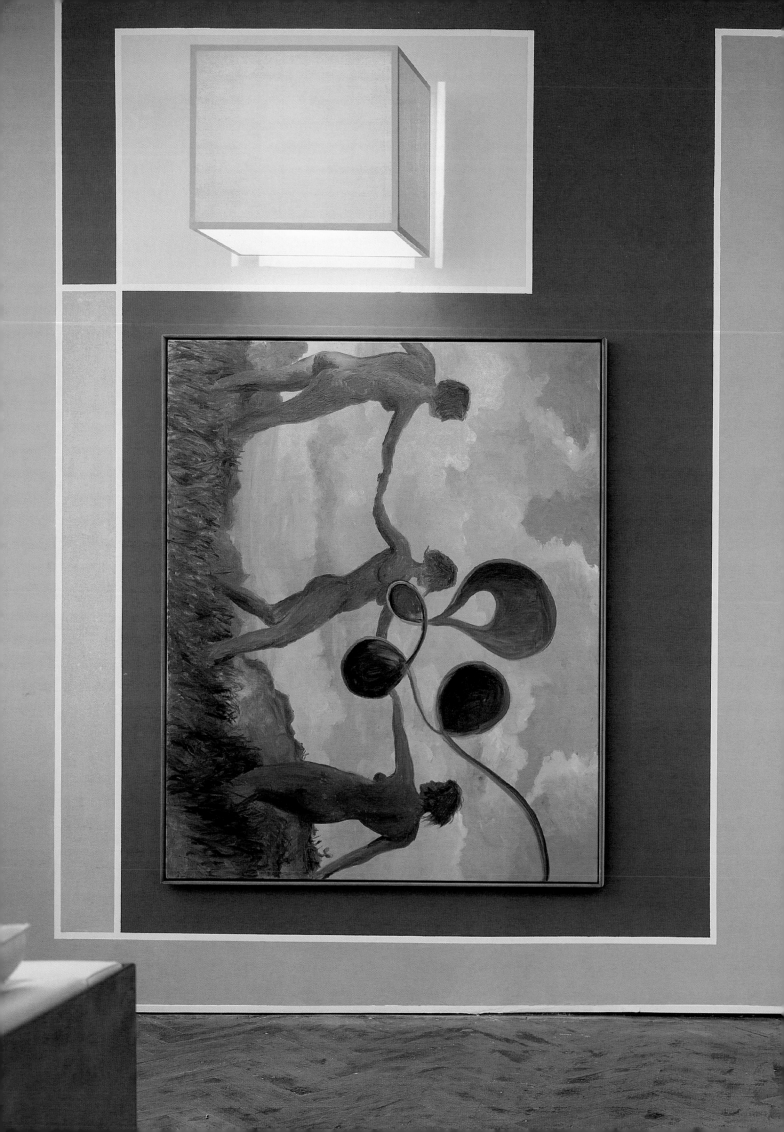

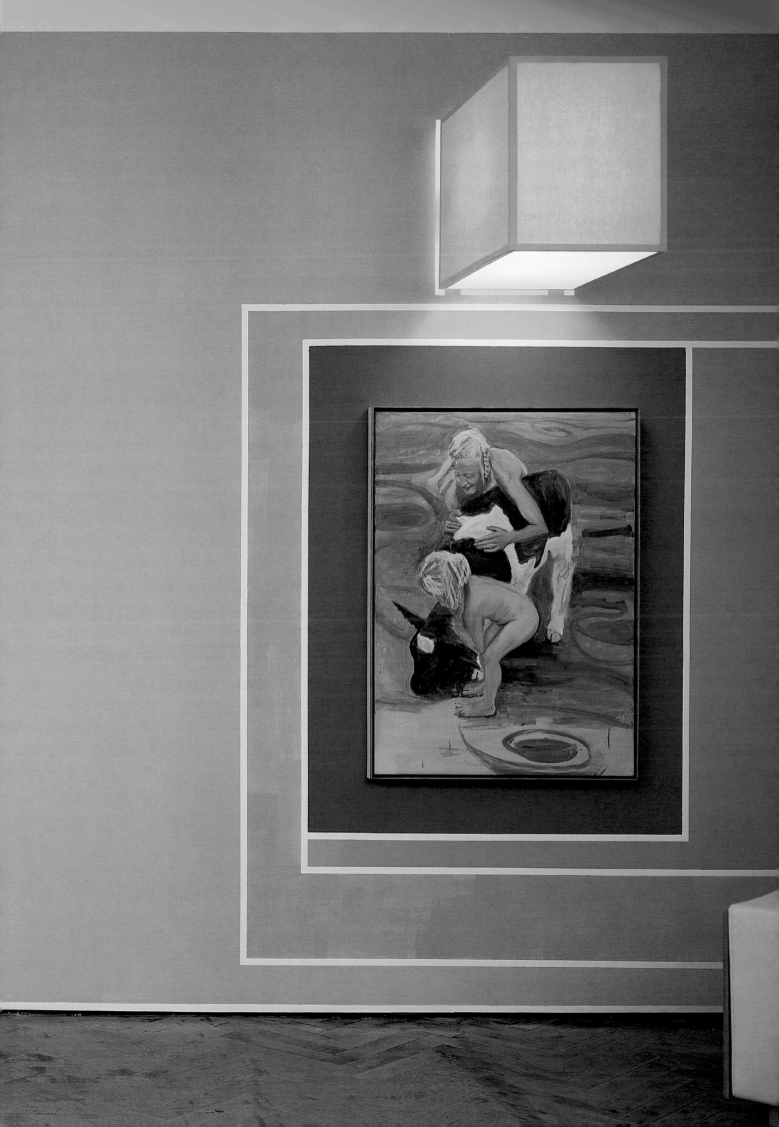

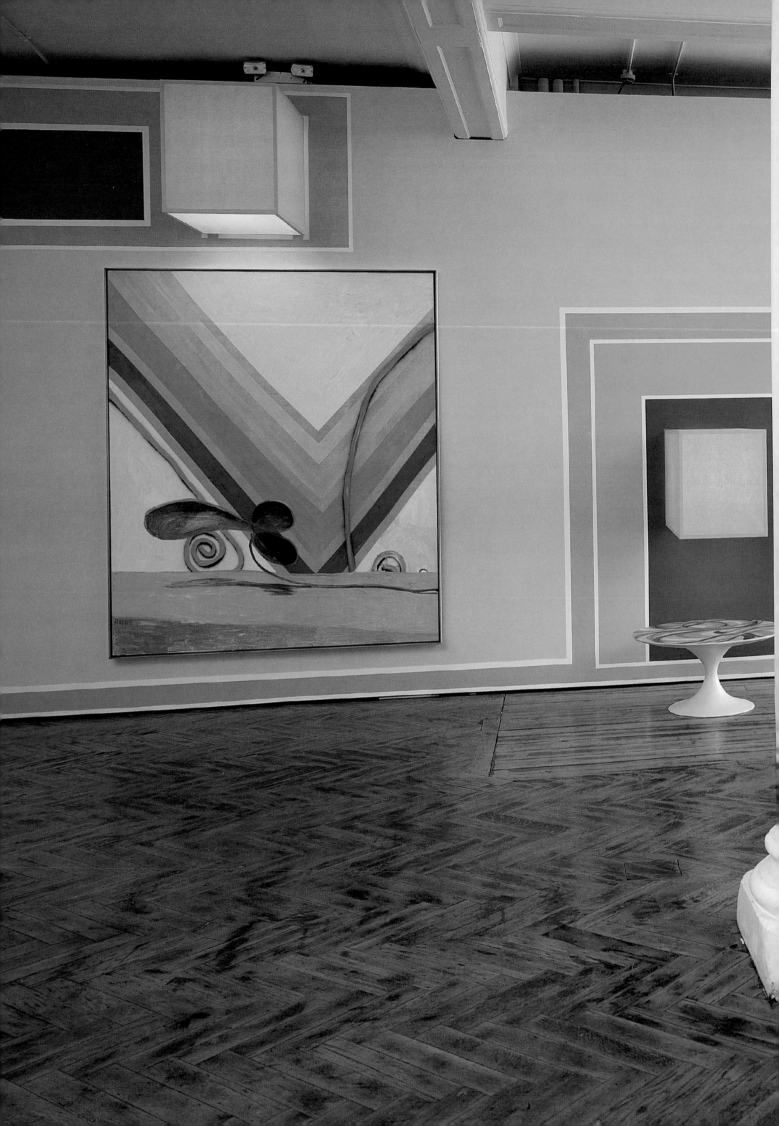

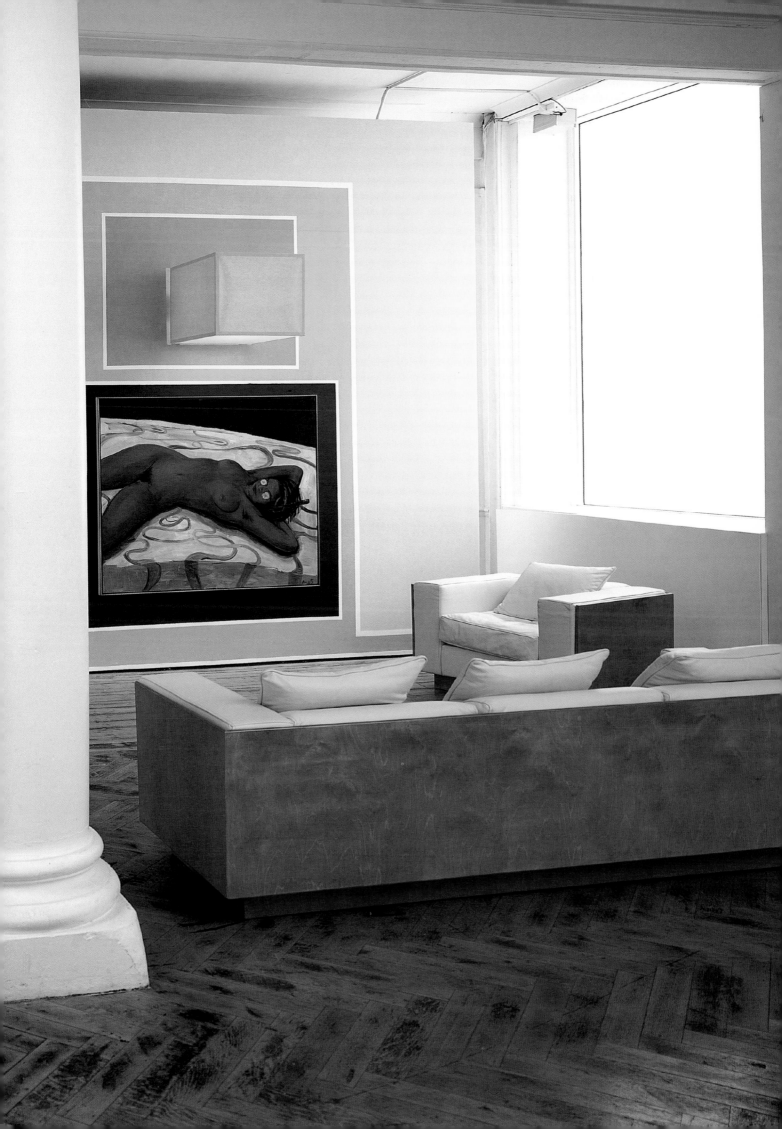

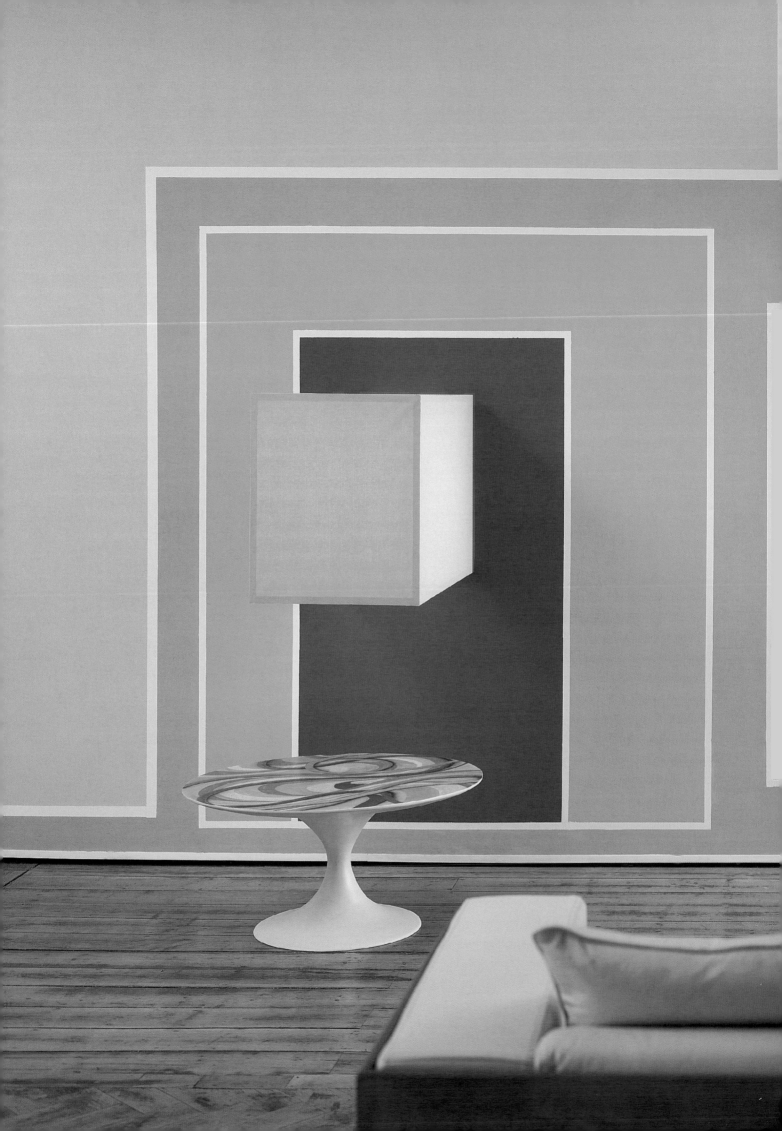

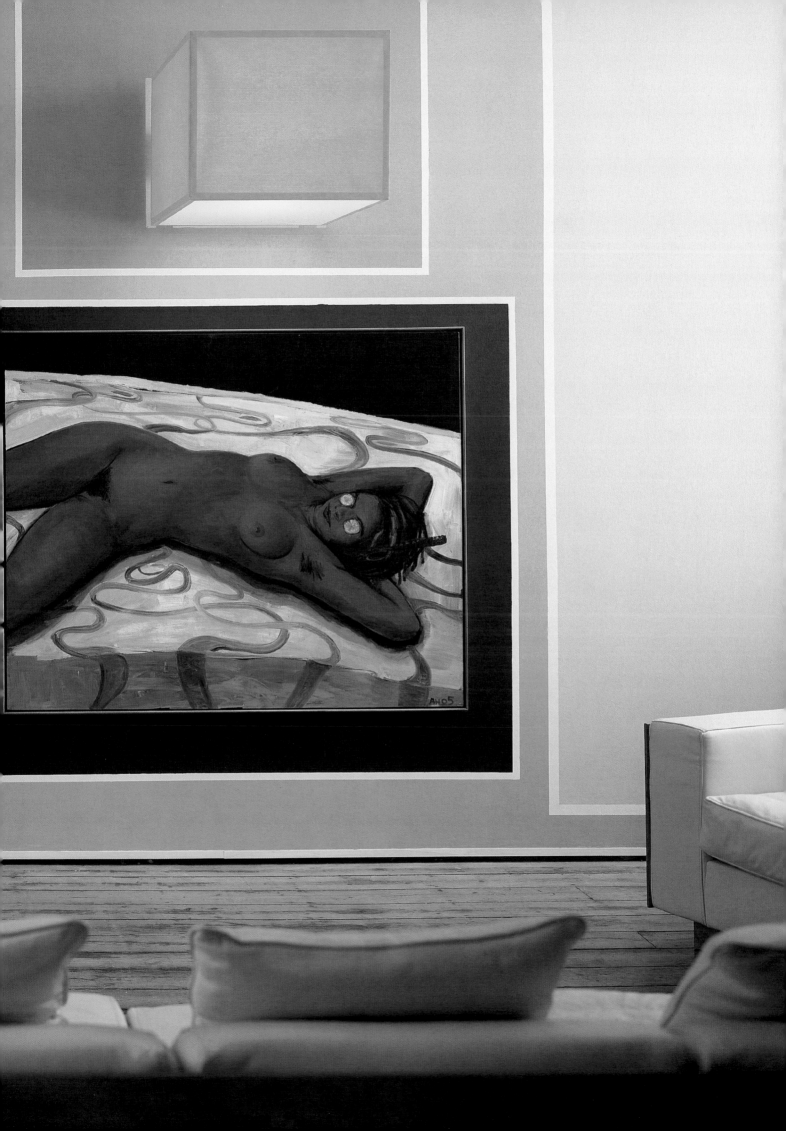

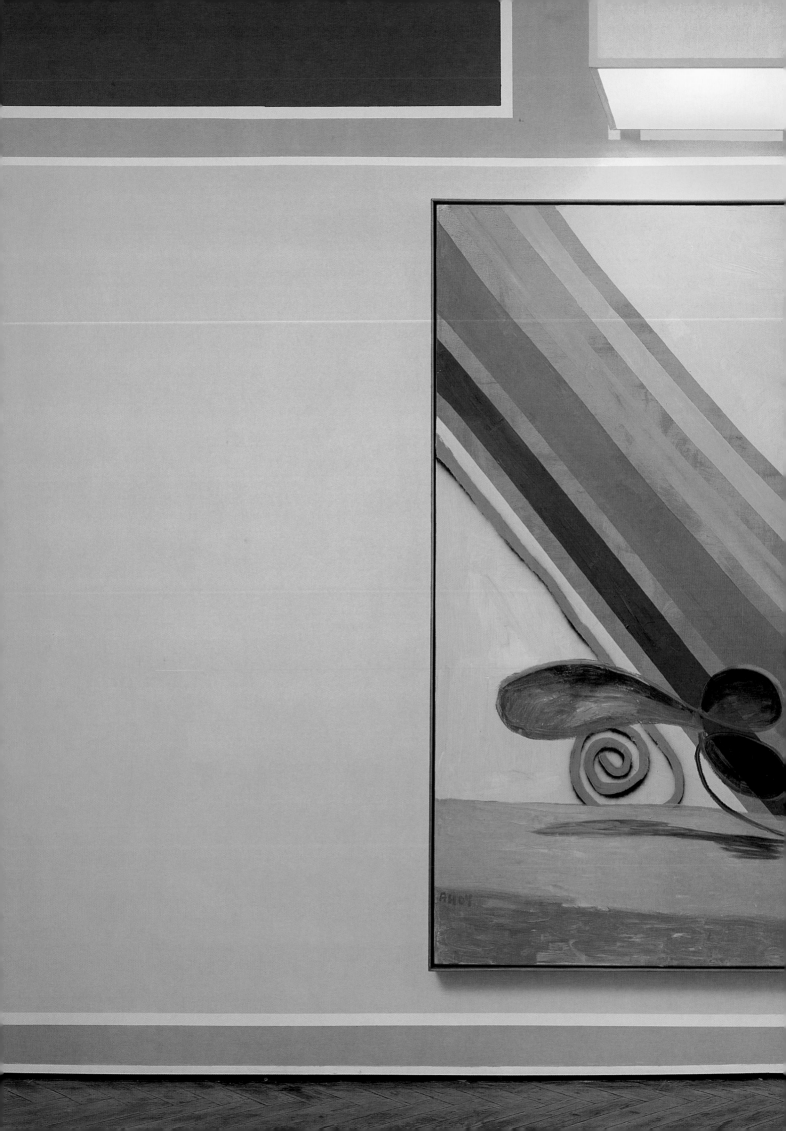

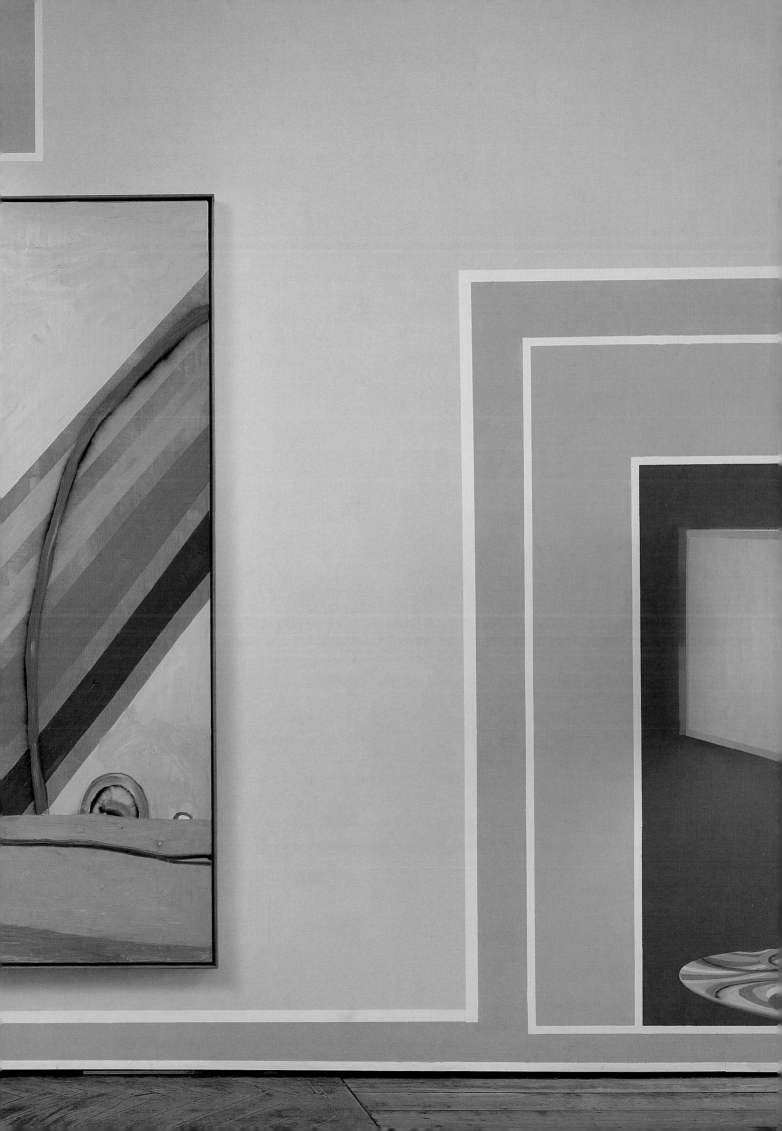

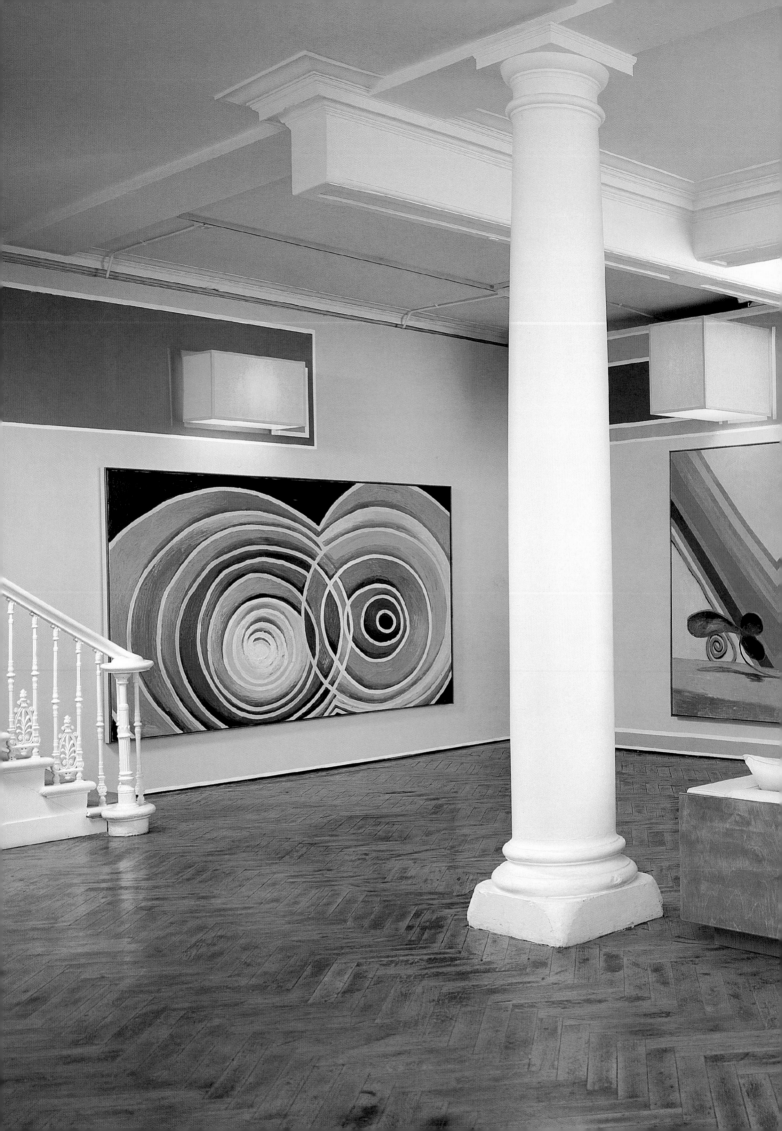

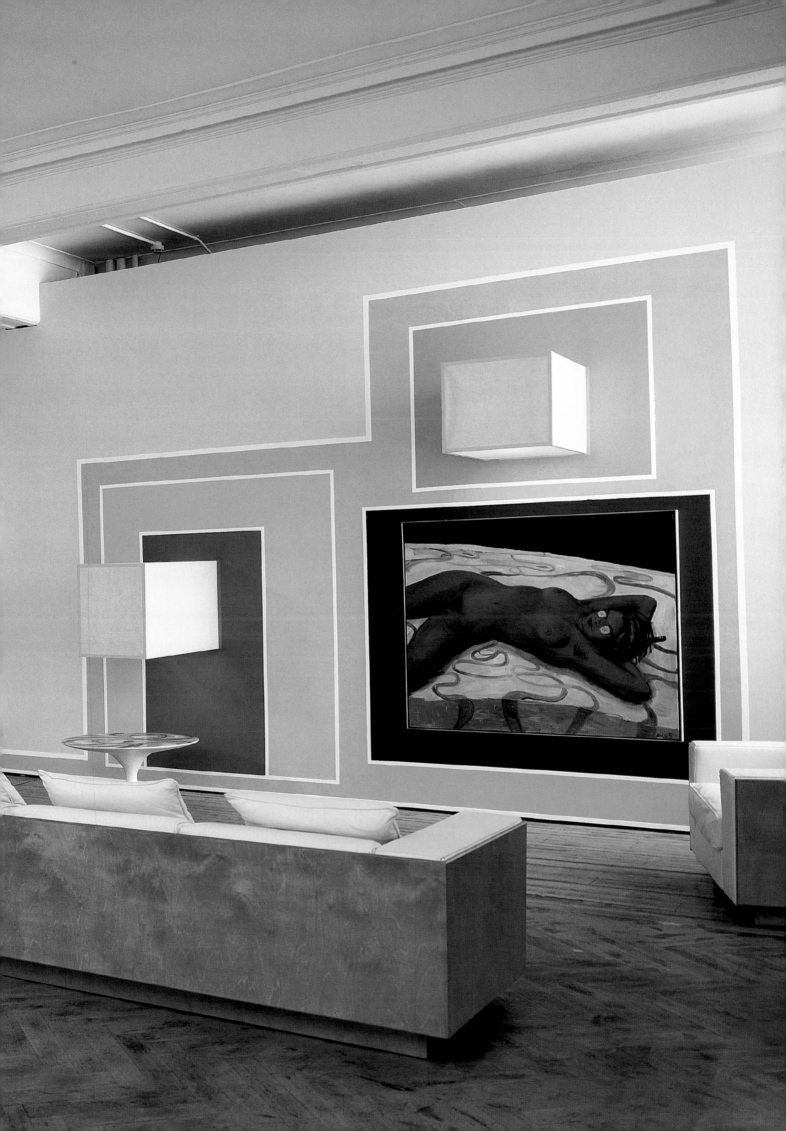

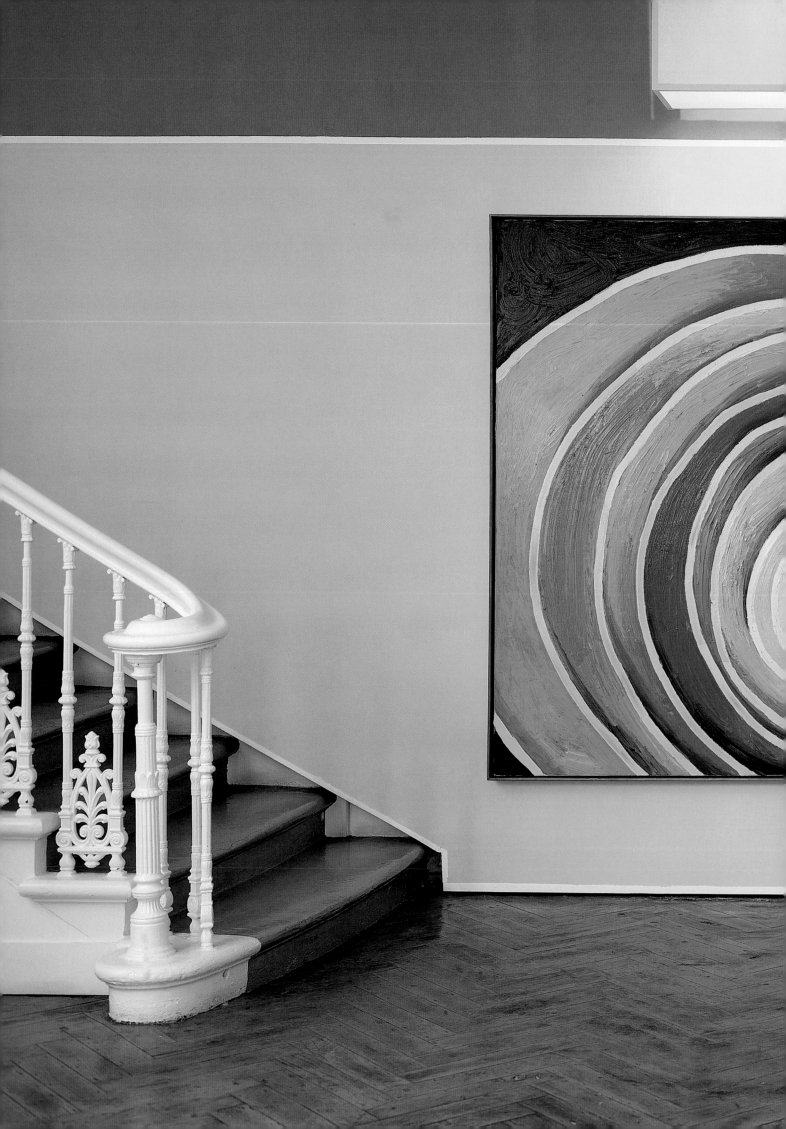

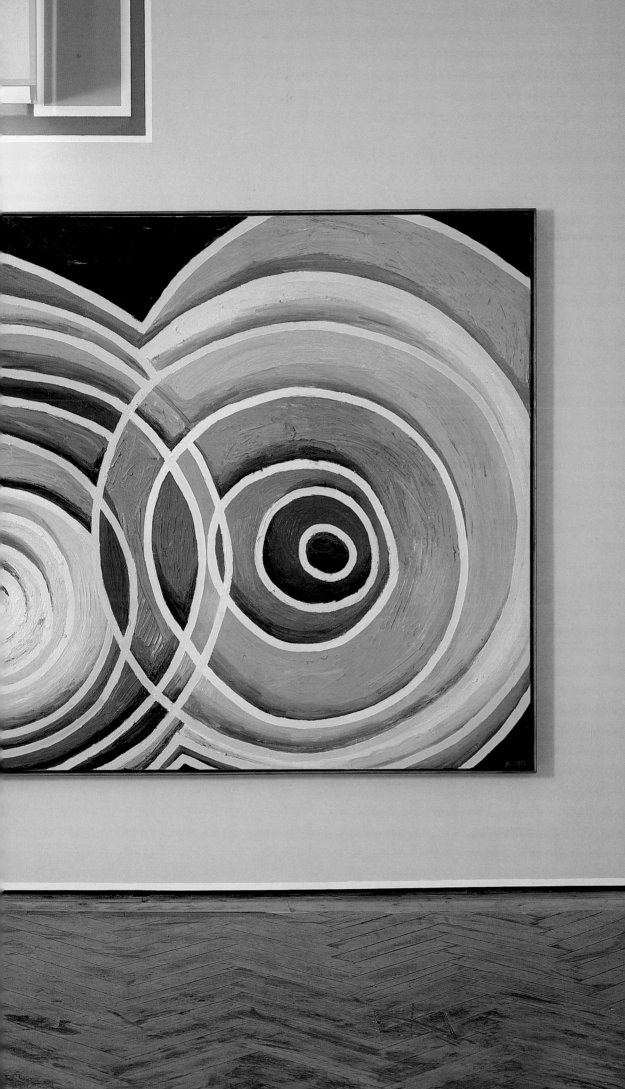

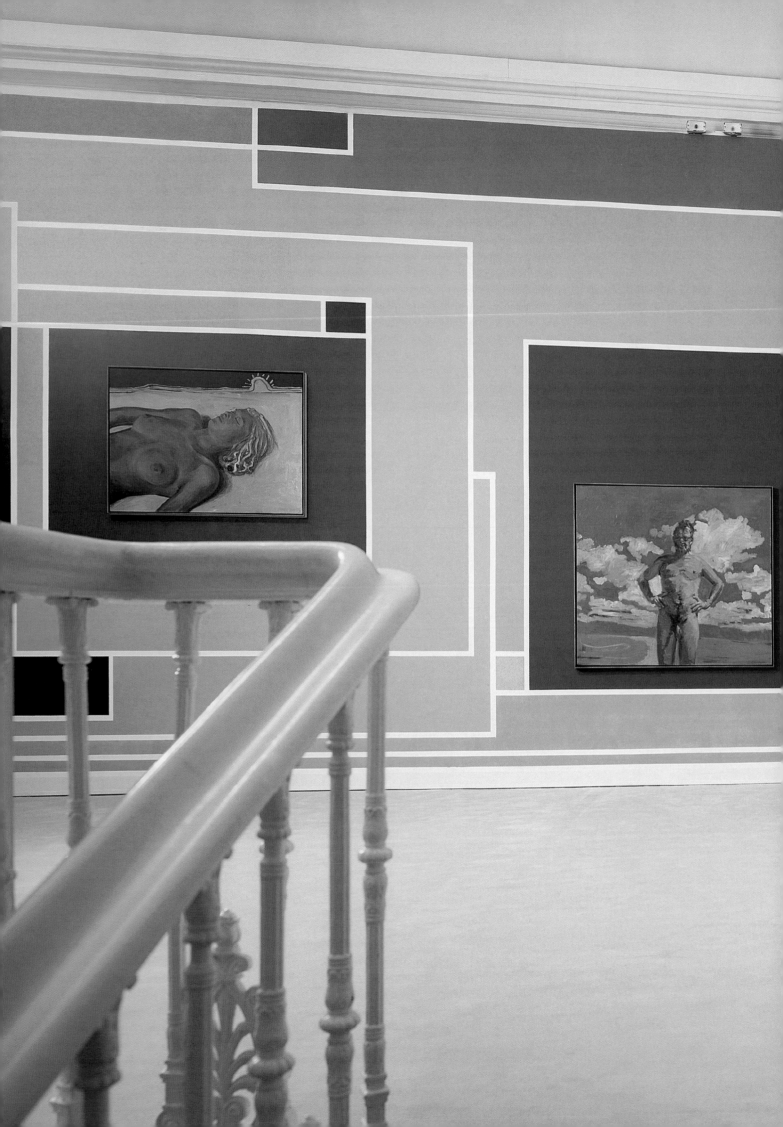

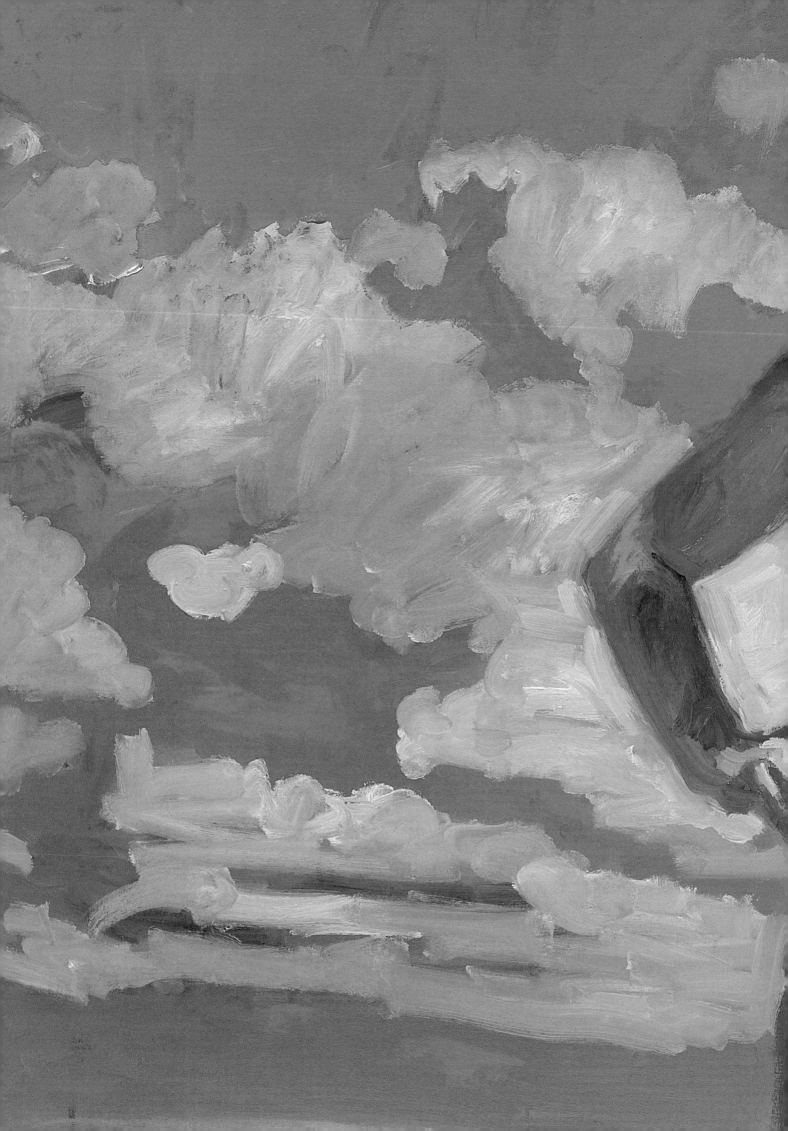

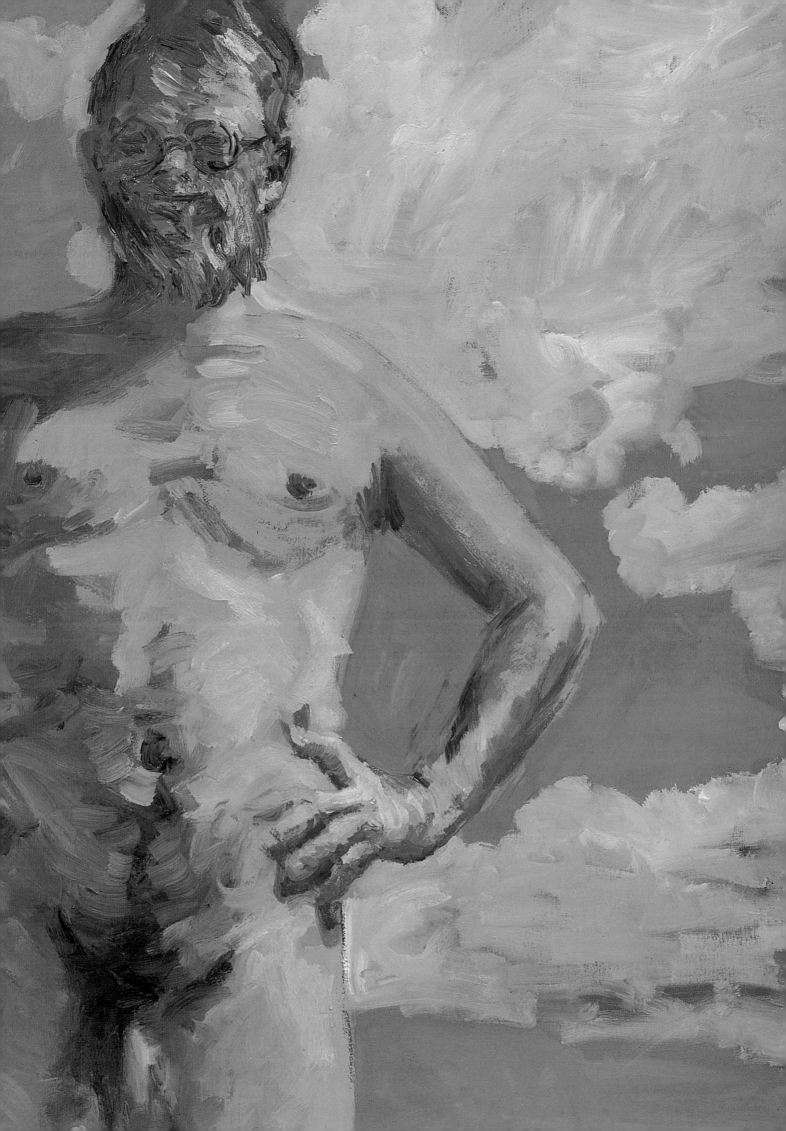

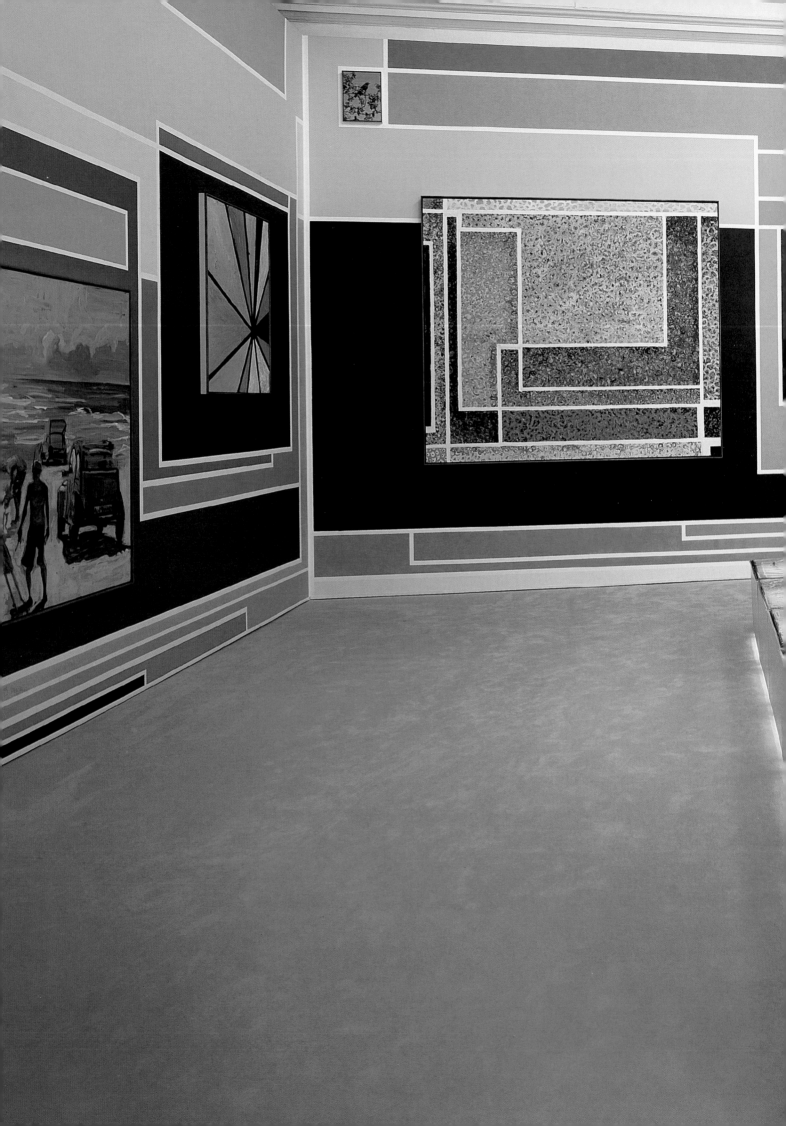

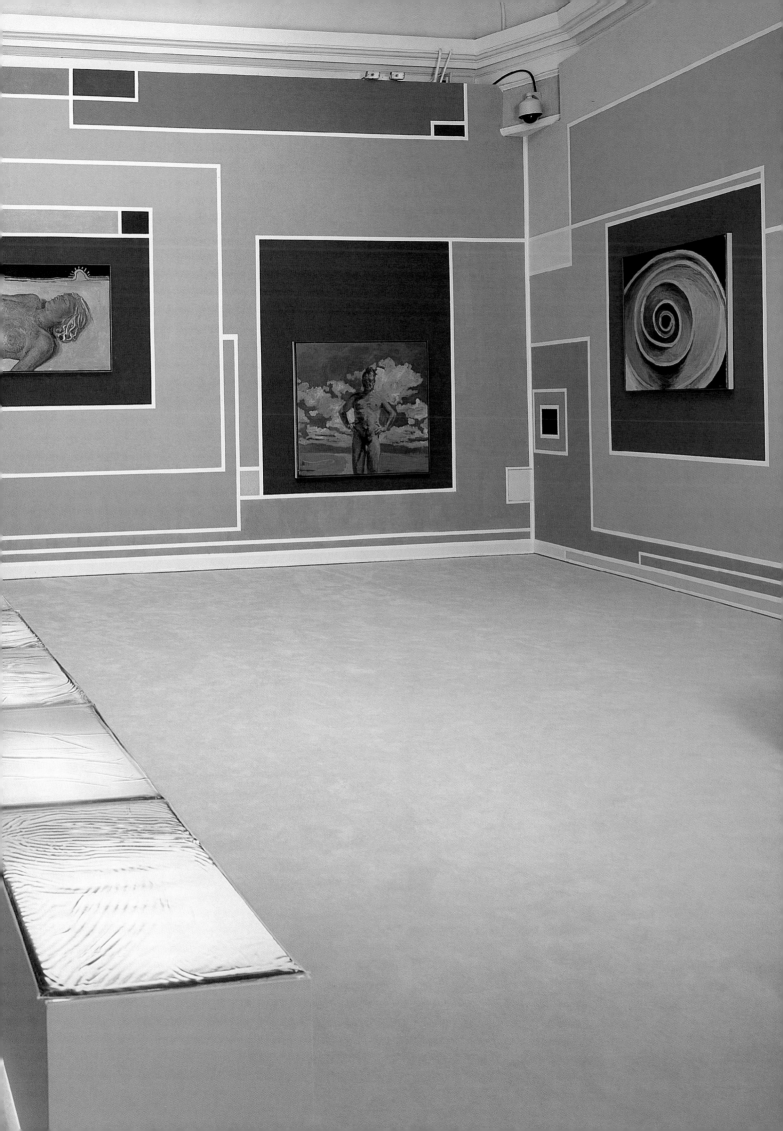

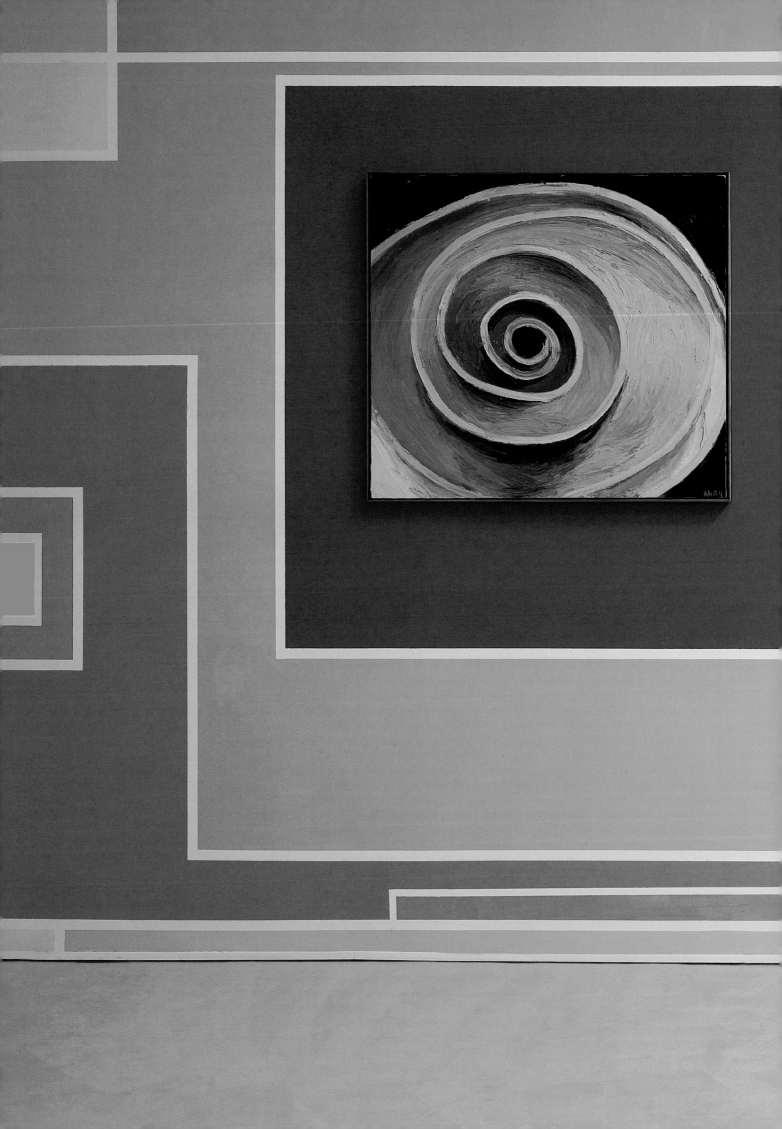

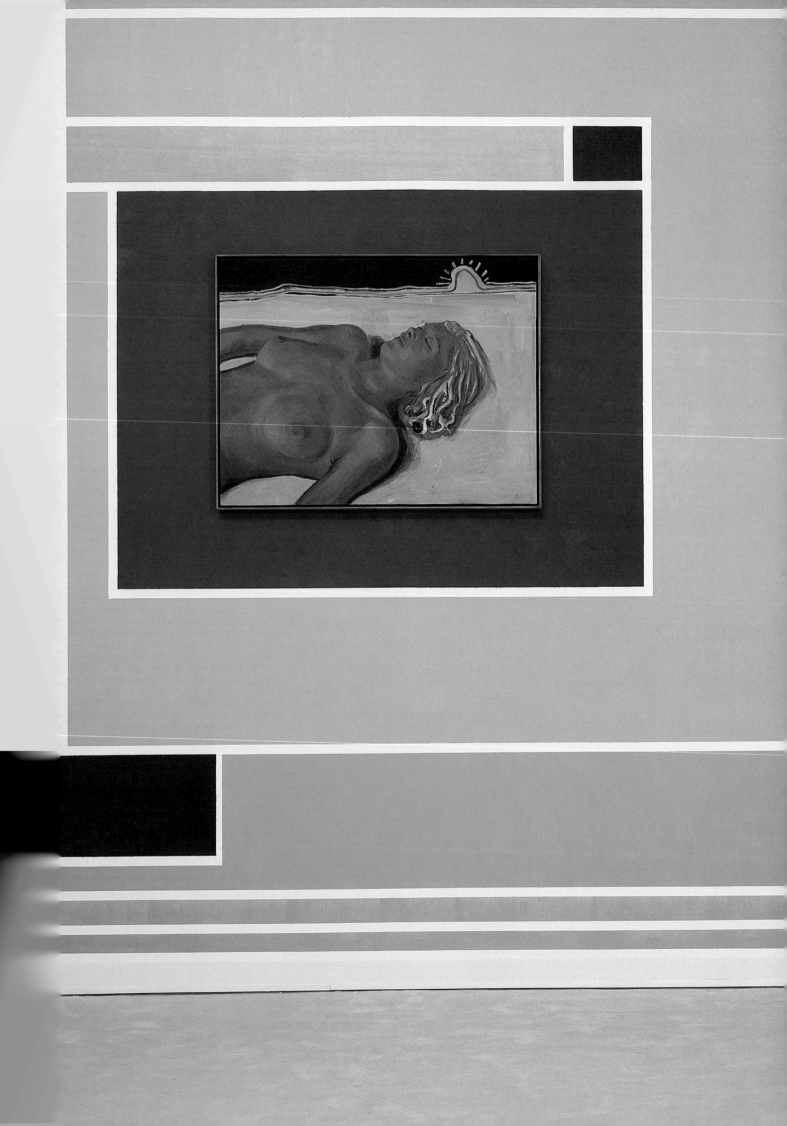

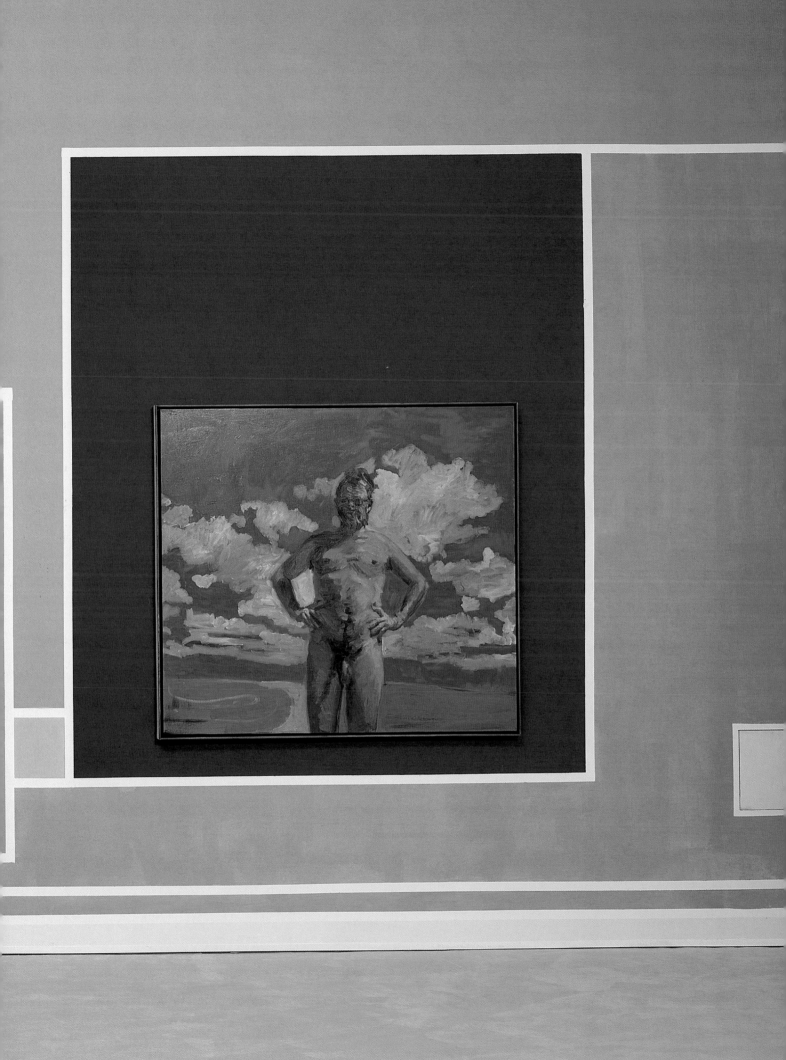

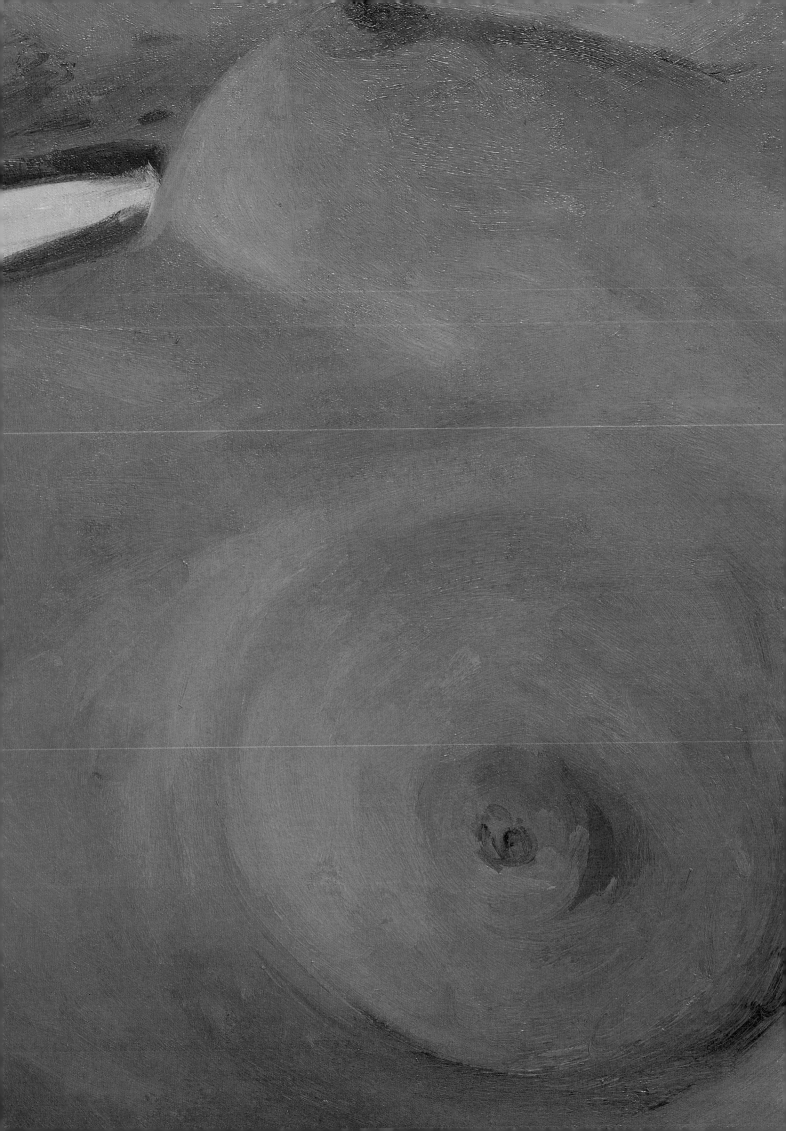

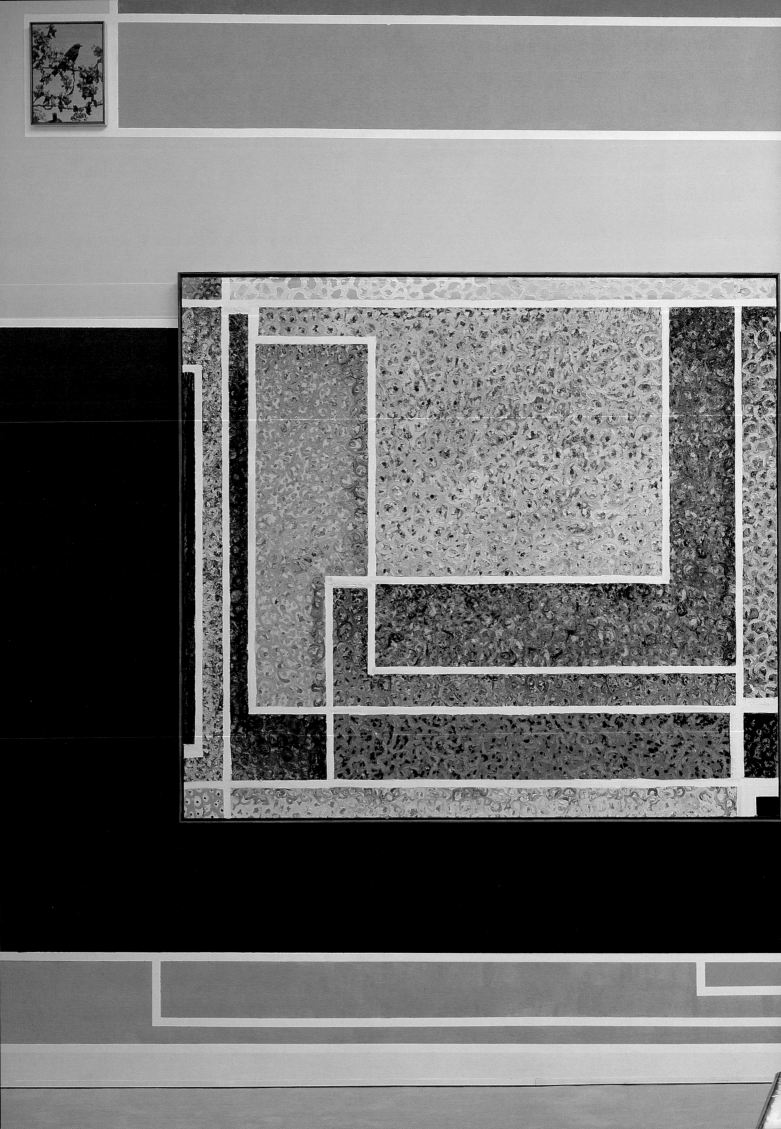

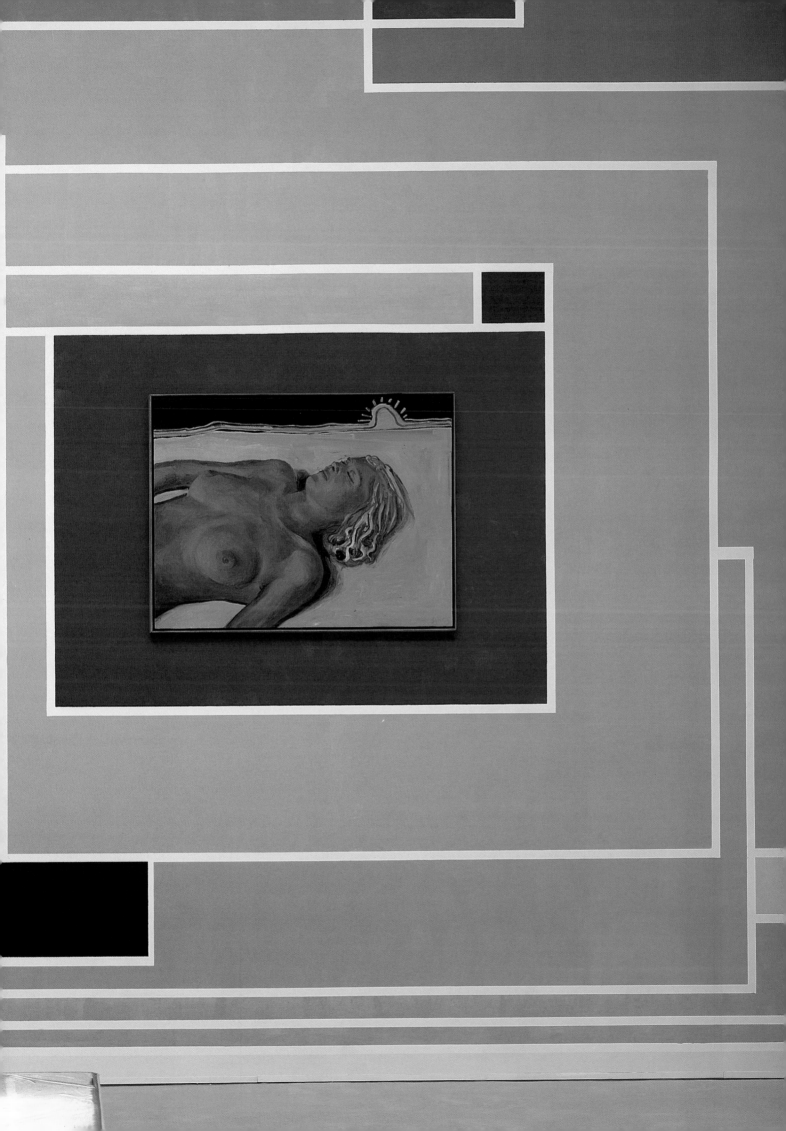

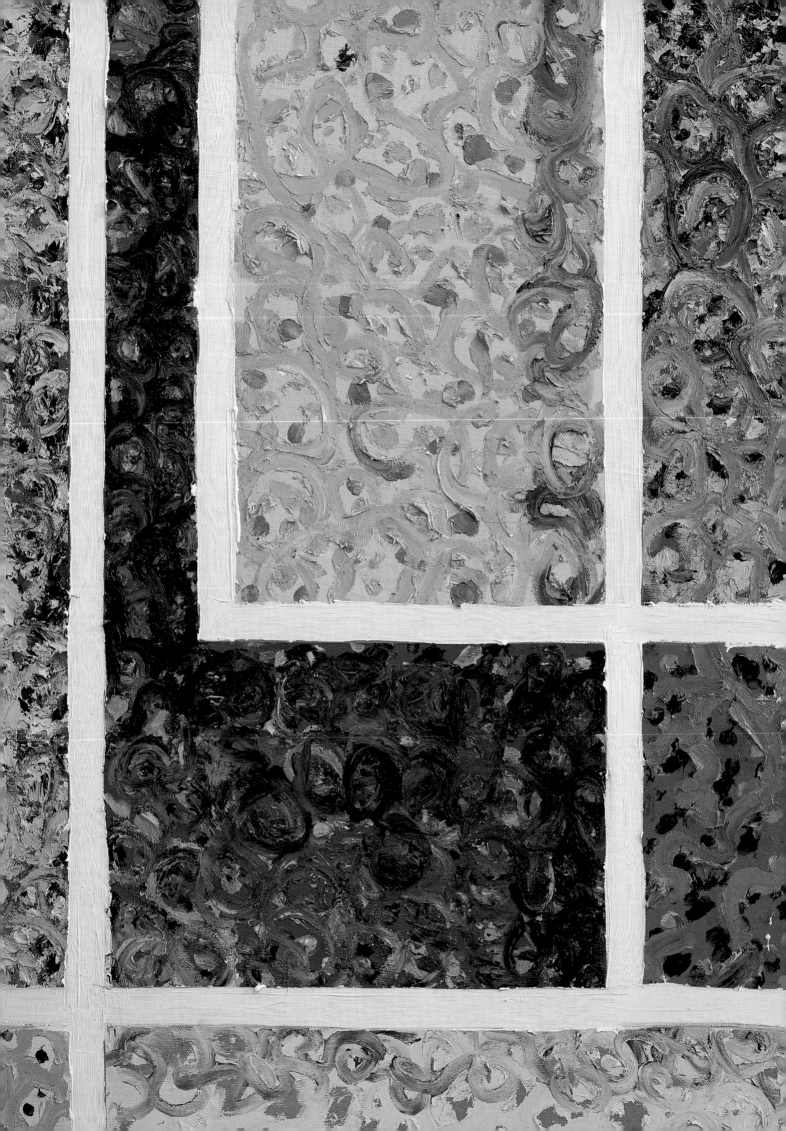

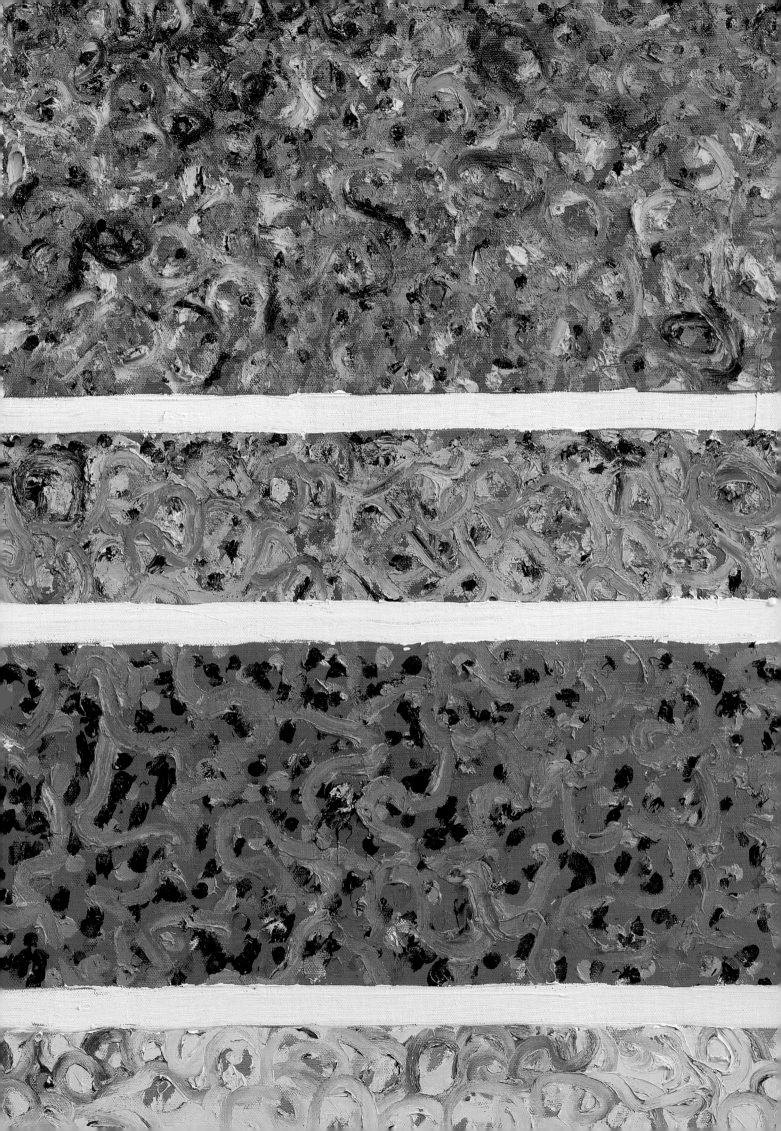

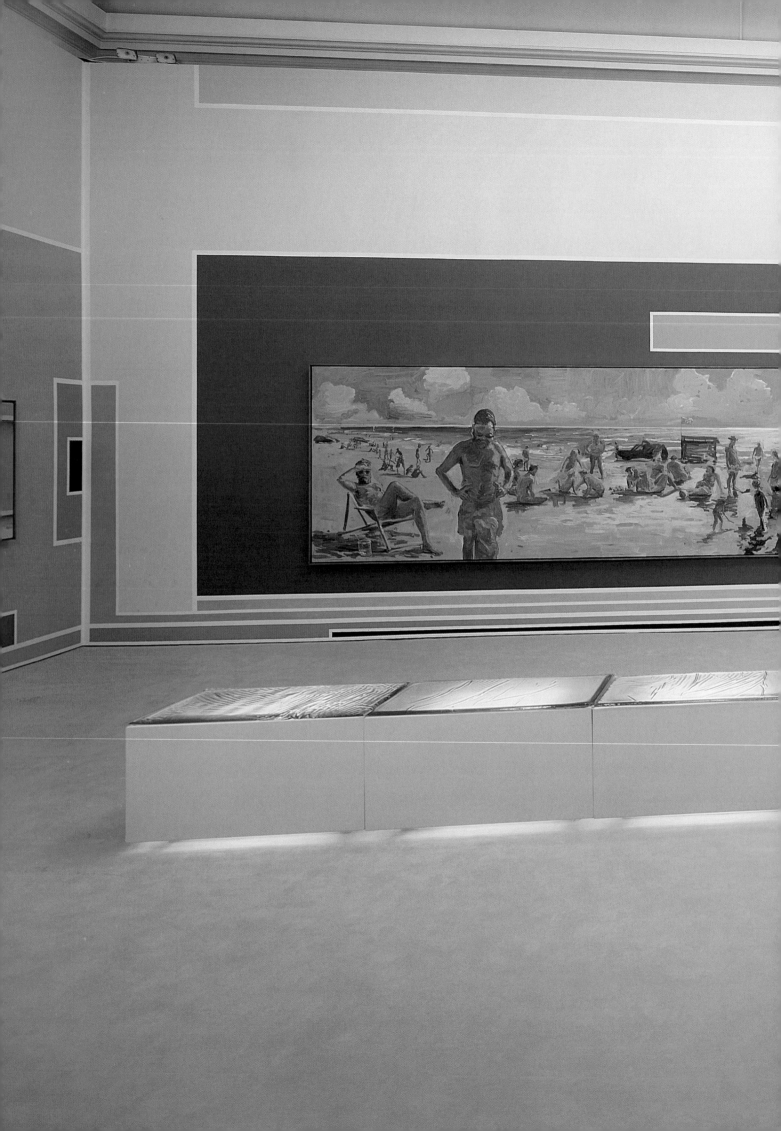

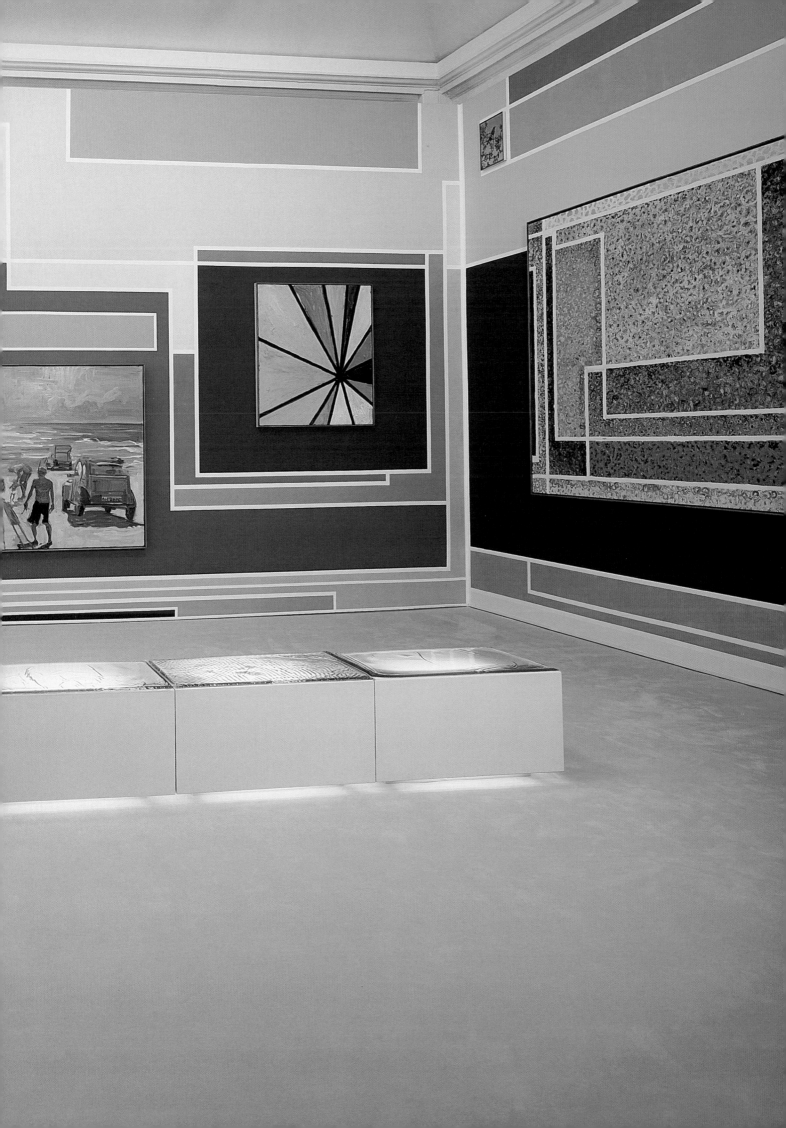

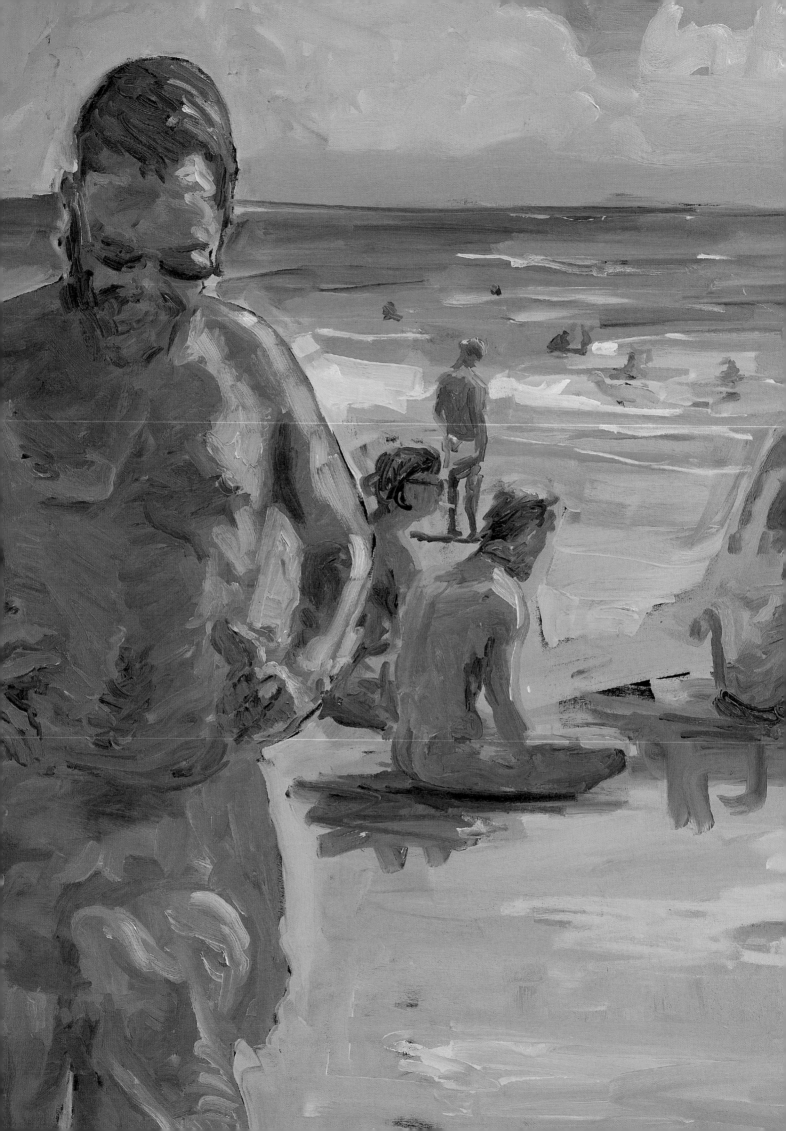

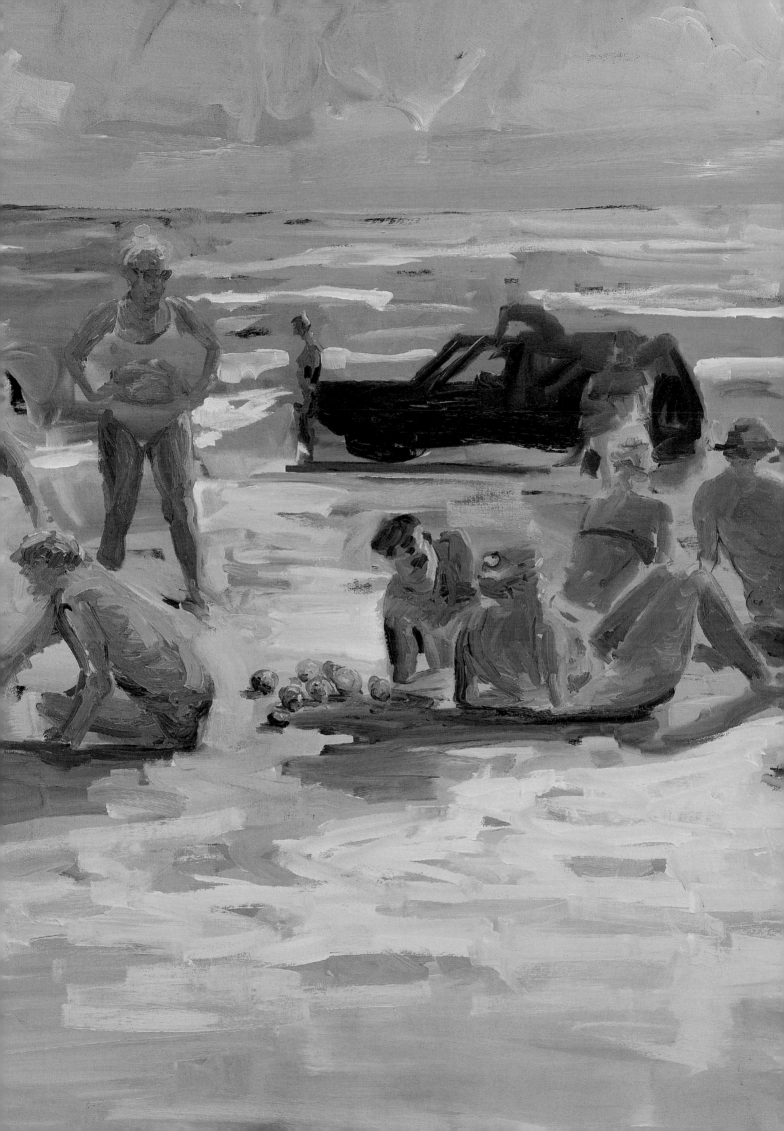

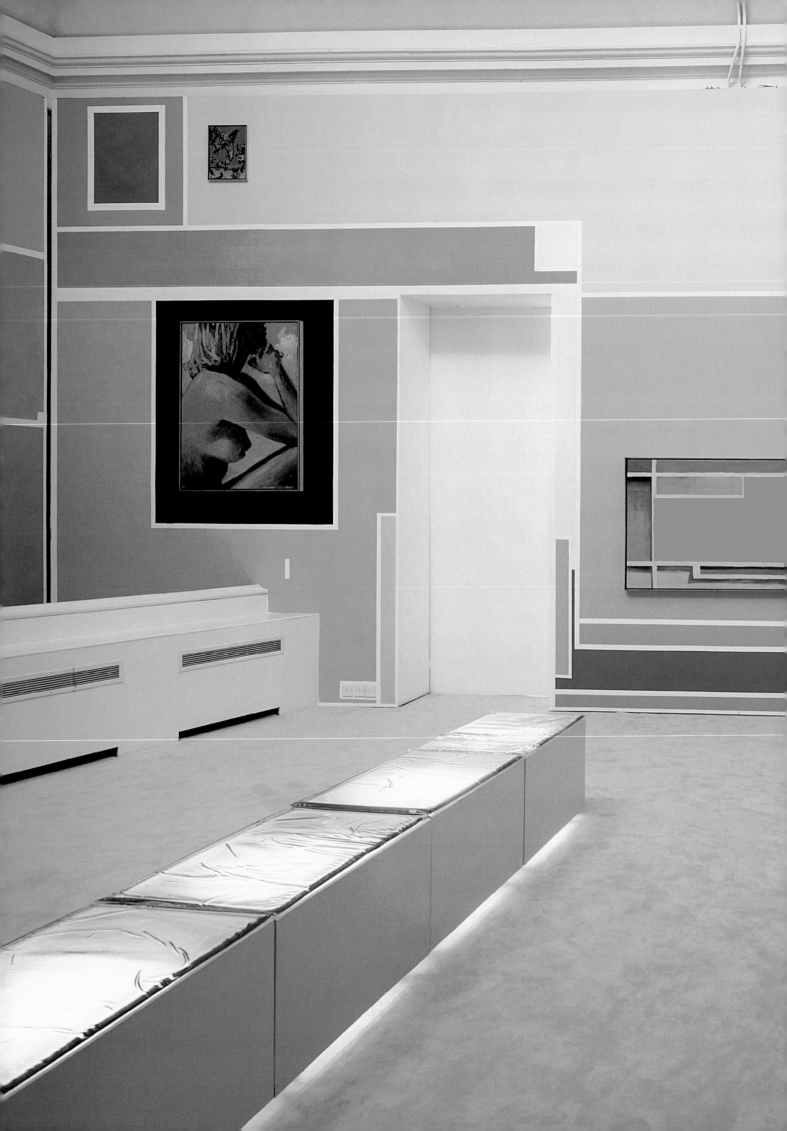

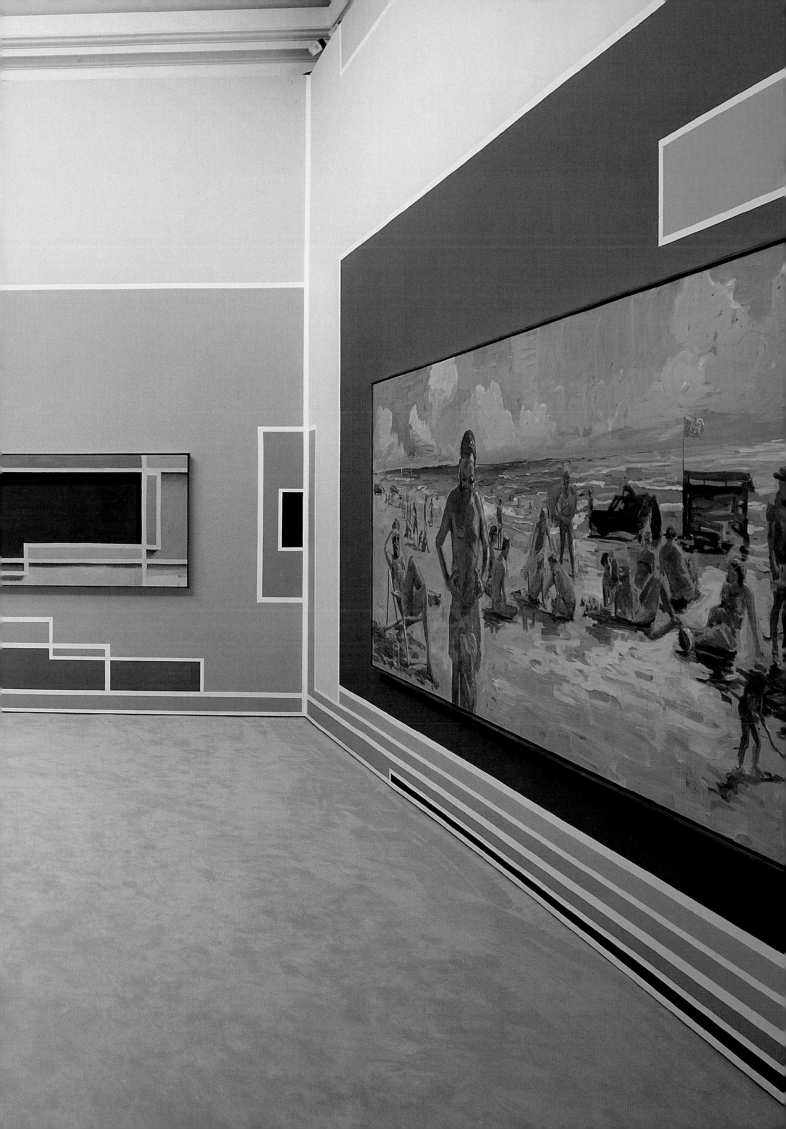

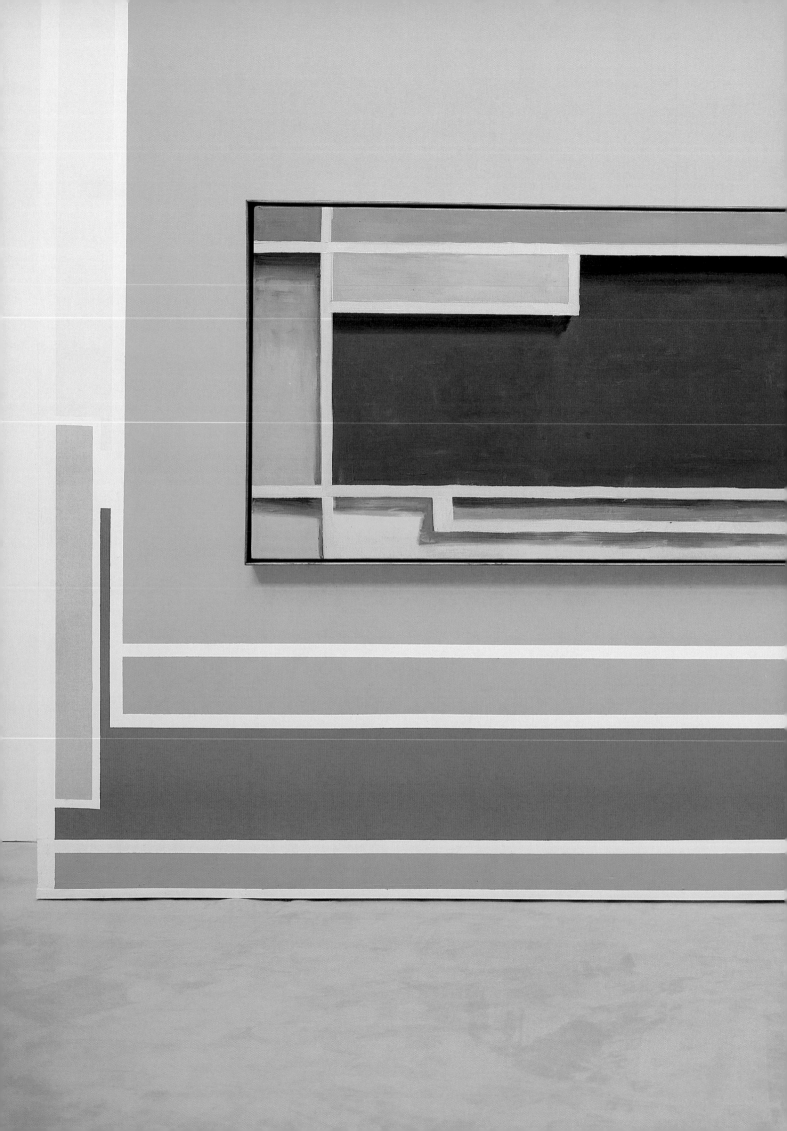

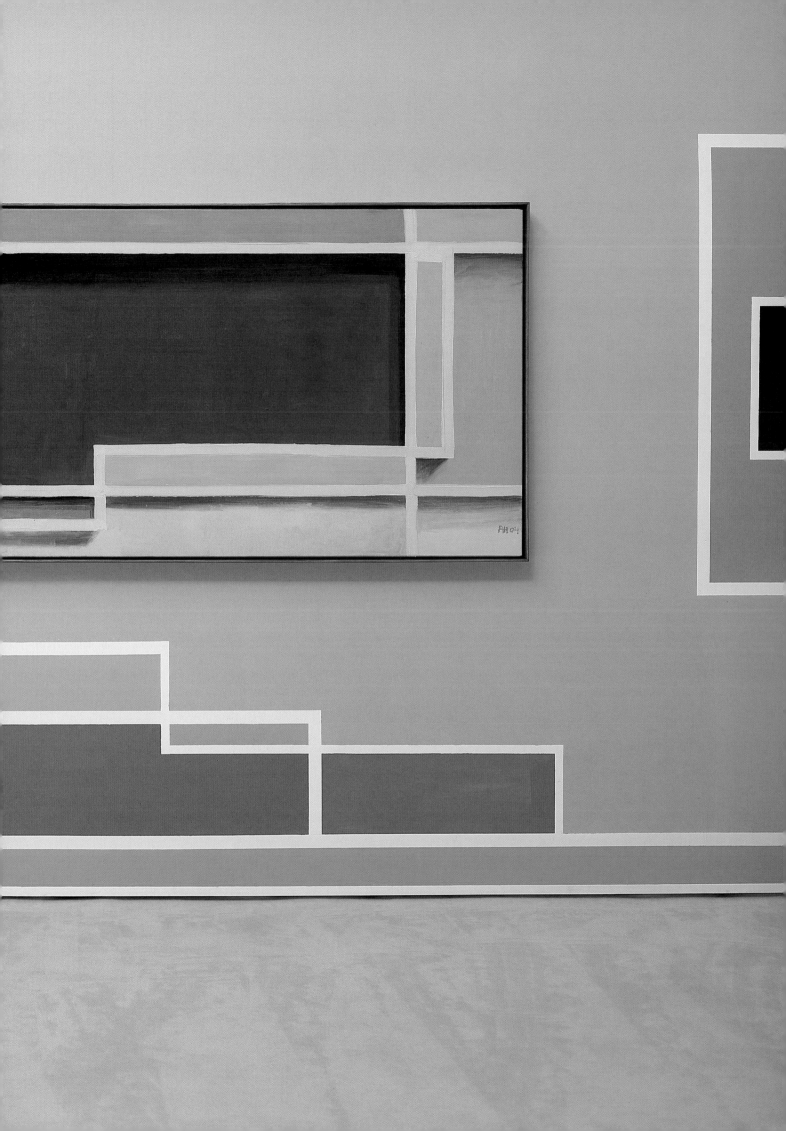

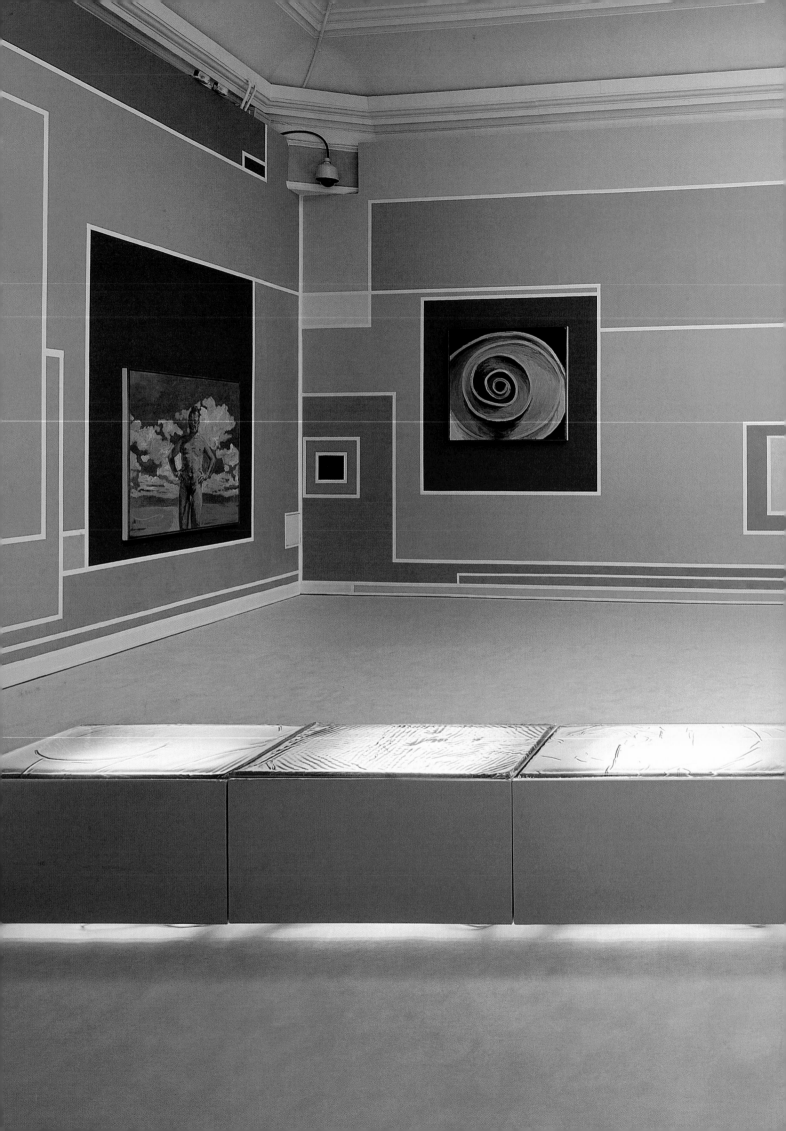

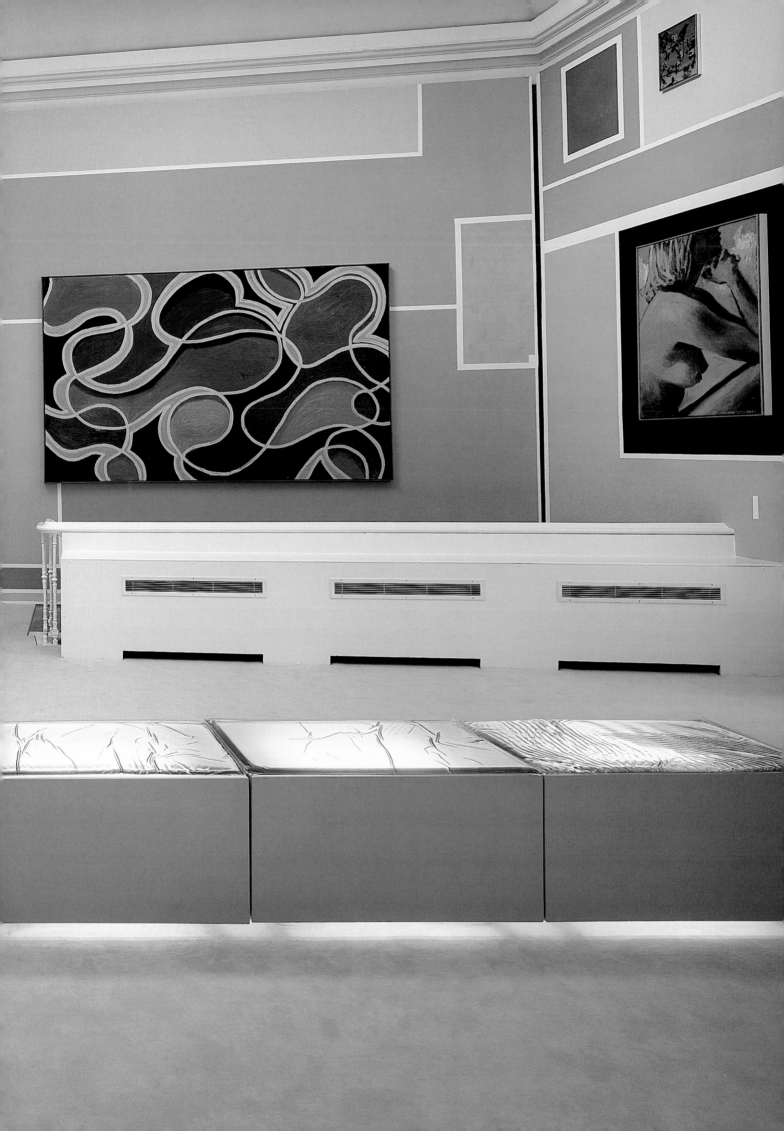

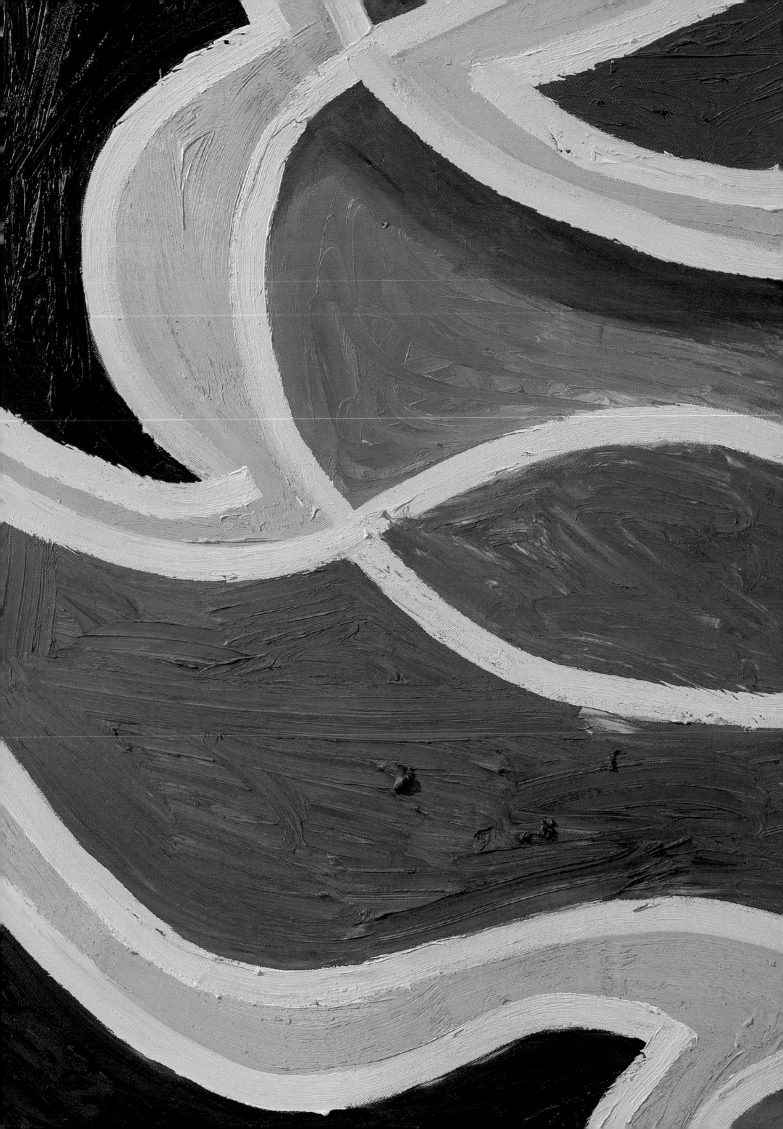

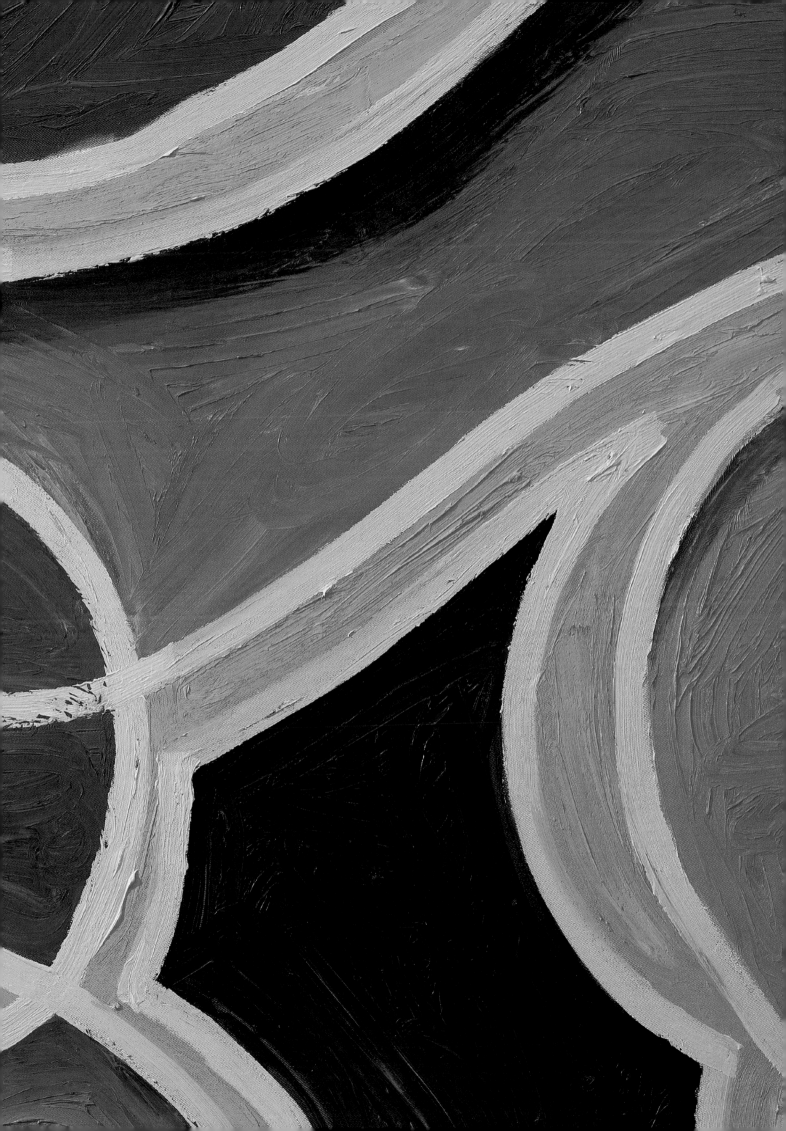

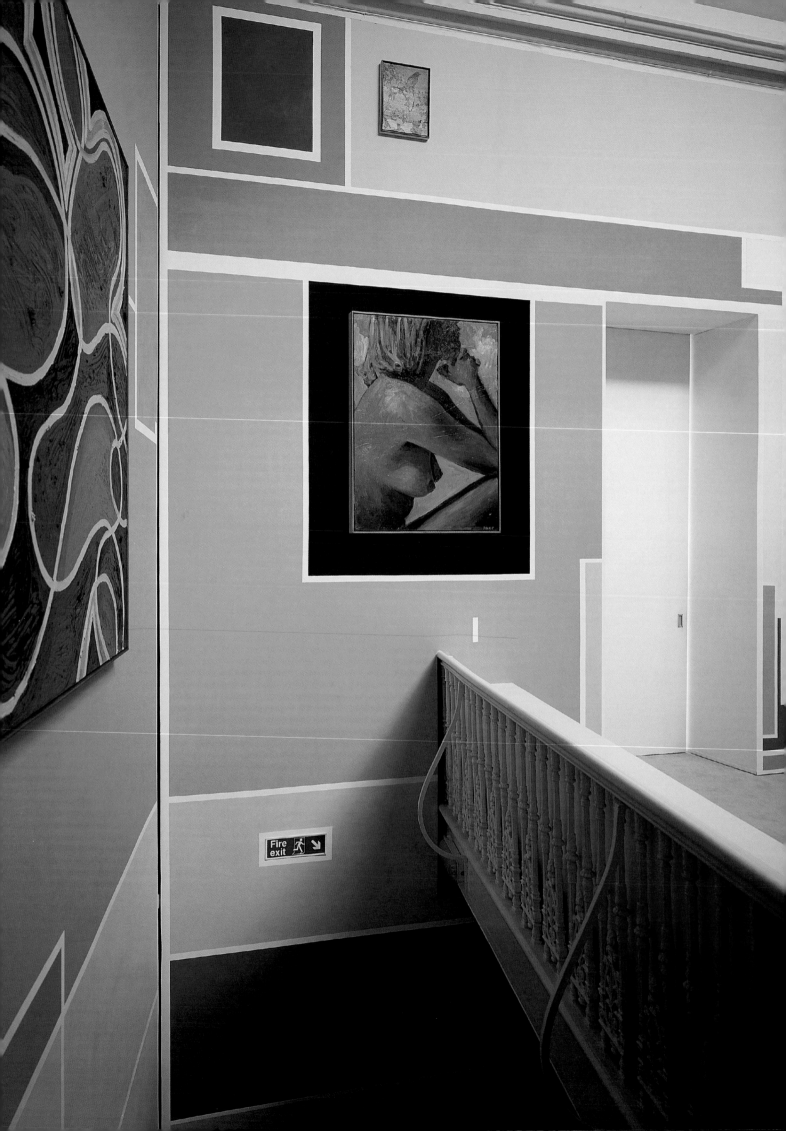

Fire exit →↘

List of works

Ground floor

01 / Interieur No. 292
2005
Oil on canvas
172.5 x 204.5 cm

02 / Pin-up No. 94
(Venus von Binenwalde)
2005
Oil on canvas
157.5 x 189.5 cm

03 / Les Baigneuses
1999
DVD on plasma screen
Dimensions variable

04 / Tisch, München
2002
DVD on plasma screen
Dimensions variable

First floor

05 / Interieur No. 238
2004
Oil on canvas
173.2 x 189.2 cm

06 / Spiel No. 2
2001
Oil on canvas
127 x 97.5 cm

07 / Blumenstilleben No. 185
2004
Oil on canvas
188.5 x 157 cm

08 / Pin-up No. 96 (Ariadne)
2005
Oil on canvas
125.5 x 157 cm

09 / Blumenstilleben No. 175
2004
Oil on canvas
220.5 x 188 cm

10 / Interieur No. 267
2004
Oil on canvas
188.5 x 314.5 cm

Second floor

11 / Interieur No. 266
2004
Oil on canvas
188 x 314.5 cm

12 / Interieur No. 265
2004
Oil on canvas
109.7 x 126 cm

13 / Sandpiper with beard
2005
Oil on canvas
125.5 x 141.5 cm

14 / Pin-up No. 95 (Danae)
2005
Oil on canvas
94.5 cm x 125.5 cm

15 / Interieur No. 249
2004
Oil on canvas
220 x 251 cm

16 / Abendlied 20.35 Uhr
2005
Oil on canvas
40 x 30 cm

17 / Interieur No. 216
2003
Oil on Canvas
125.5 x 110 cm

18 / Strandfahrt No. 5
2005
Oil on canvas
157 x 581 cm

19 / Interieur No. 275
2004
Oil on canvas
94.9 x 314.7 cm

20 / Pin-up No. 97 (Lupa)
2005
Oil on canvas
126.5 x 94.5 cm

21 / Abendlied 21.30 Uhr
2005
Oil on canvas
40 x 30 cm

02 / 01

02 / detail

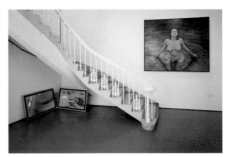

04 / 03 / 02

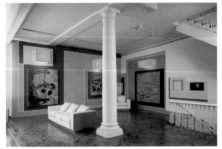

07 / 06 / 05

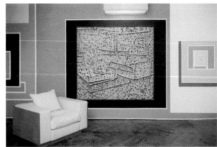

05

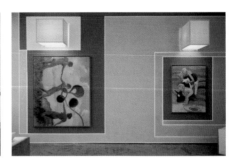

07 / 06

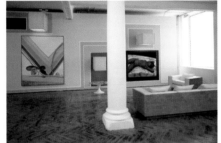

09 / 08

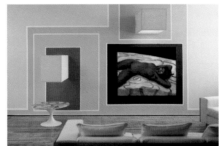

08

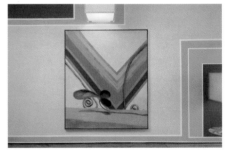

09

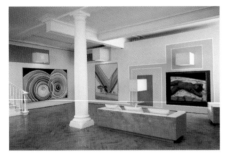

10 / 09 / 08

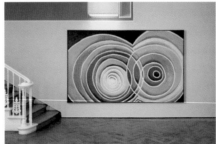

10

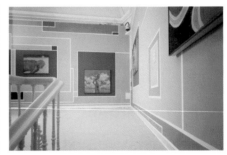

14 / 13 / 12 / 11

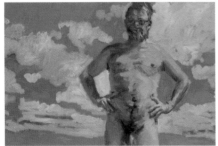

13 / detail

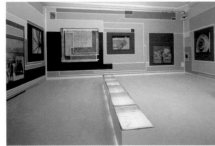

18 / 17 / 16 / 15 / 14 / 13 / 12

12

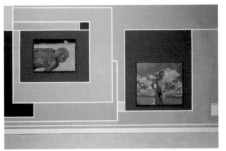 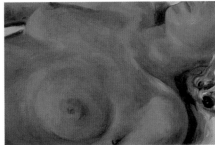 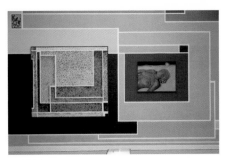

14 / 13                    14 / detail                    15 / 14

 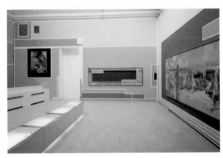 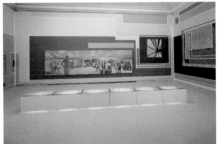

15 / detail                19 / 18 / 17 / 16 / 15         18 / detail

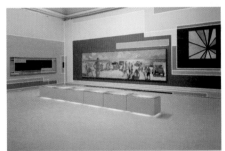 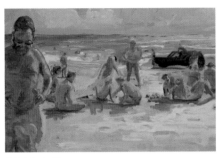 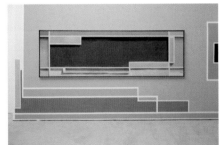

19 / 18 / 17               21 / 20 / 19 / 18             19

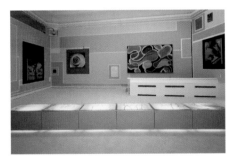  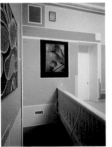

13 / 12 / 11 / 21 / 20      11 / detail                   11 / 21 / 20

Works listed left to right

Anton Henning

1964  Born in Berlin
       Lives in Berlin and Manker

       Selected Solo Exhibitions

2005  MARTa Herford, Herford / DE
       Museum Haus Esters,
       Krefeld / DE
       Anton Henning
       Arndt & Partner, Berlin / DE
       Anton Henning
       Wohnmaschine, Berlin / DE
       Sandpipers, Lizards & History
       Haunch of Venison,
       London / UK
       Frankfurter Salon
       Dornbracht Installation
       Projects ® 2005, Museum
       für Moderne Kunst, Frankfurt
       am Main / DE

2004  Tragedy, Sunburns
       & Still-lives
       Christopher Grimes Gallery,
       Santa Monica / USA
       Eleven nearly immaculate
       paintings
       Galerie Bob van Orsouw,
       Zürich / CH
       Interieur No. 253
       Arp Museum Bahnhof,
       Rolandseck (permanent
       installation) / DE

2003  Scrummage
       Vous Etes Ici, Amsterdam / NE
       Was ihr wollt!
       Christopher Grimes Gallery,
       Santa Monica / USA
       Salon, Arndt & Partner,
       Berlin / DE
       Sommertagstraum
       Wohnmaschine, Berlin / DE
       Ziemlich schöne Malereien
       Kunstmuseum Lucerne / CH

2002  Surpassing Surplus
       De Pont Foundation,
       Tilburg / NL
       Let Dandib paint
       Blind Date, Kunstverein,
       Hannover / DE

2001  Interieur No. 117
       Städtische Ausstellungshalle
       Am Hawerkamp, Münster / DE
       Interieurs 2001
       Vous Etes Ici, Amsterdam / NL
       Interieurs 2001
       Wohnmaschine, Berlin / DE
       Interieur No. 97
       Kunstverein Ulm / DE
       Interieur No. 79

       & Metabolism at Dusk
       Entwistle, London / UK

2000  Nach Indien
       Galerie Andreas Schlüter,
       Hamburg / DE

1999  The Manker Melody Makers
       Lounge
       Galerie für Zeitgenössische
       Kunst, Leipzig / DE
       Tomorrow is the Cool
       Galerie Eugen Lendl,
       Graz / AT

1998  Too much of a good thing…
       Kasseler Kunstverein / DE,
       Espace des Arts, Chalon-sur-
       Saône / FR, Kunstverein
       Heilbronn / DE

1997  Some day my prince will come
       Wohnmaschine, Berlin / DE

1995  Soup
       White Columns,
       New York / USA

1990  New Work
       University Art Museum,
       Oklahoma, Vrej Baghoomian
       Gallery, New York / USA

1989  Photoüberarbeitungen
       Galerie Hilger, Wien / AT

       Selected Group Exhibitions

2005  Schönheit der Malerei
       Städtische Galerie
       Delmenhorst / DE
       Ergriffenheit
       Kunstmuseum, Luzern / CH
       Blumenstück
       Künstlers Gluck
       Museum Morsbroich / DE
       (my private) HEROES
       MARTa Herford, Herford / DE

2004  Die Wirklichkeit in der Falle
       Künstlerverein Malkasten,
       Düsseldorf / DE
       Christopher Grimes Gallery,
       Los Angeles / USA
       Die neue Kunsthalle IV
       Kunsthalle Mannheim / DE
       Made in Berlin, Artforum
       Berlin, Halle 11.2 (curated
       by Zdenik Felix) / DE

2003  Franz von Lenbach und
       die Kunst heute
       Museum Morsbroich,

Leverkusen / DE
Adieu Avantgarde –
Willkommen zu Haus
Ludwig Forum Aachen / DE
Ornament
Luitpoldblock, Münich / DE

2002 La Biennale de Montreal,
Montreal / CA
The image in use
Künstlerhaus Palais Thurn
und Taxis, Bregenz / AT
Stories. Erzählstrukturen in
der zeitgenössischen Kunst
Haus der Kunst, Münich / DE
Bilder aus Berlin
Christopher Grimes Gallery,
Santa Monica / USA

2001 Kunst und Kur. Ästhetik
der Erholung
Kunsthaus Meran / DE
Fotografierte Bilder.
Wenn Maler und Bildhauer
fotografieren
Museum Bochum / DE
Szenenwechsel XX
Museum für Moderne Kunst,
Frankfurt am Main / DE
Imagination – Romantik
Stadtmuseum Jena / DE,
Kunstmuseum Brunn / DE,
Galway Art Center / IE
Das flache Land
Brandenburgische
Kunstsammlungen
Cottbus / DE
Viel Spaß. Aspect de la scène
actuelle allemande
Espace Paul Ricard,
Paris / FR
playing amongst the ruins
Royal College of Art,
London / UK
Offensive Malerei
lothringer 13 / halle,
Münich / DE

2000 Malkunst
Fondazione Mudima,
Mailand / IT
Dia / Slide / Transperency
Kunstamt Kreuzberg /
Bethanien und NGBK,
Berlin / DE
One of those days
Mannheimer
Kunstverein / DE
Premio Michetti 2000
Museo Michetti, Francavilla
al mare / IT
Ich ist etwas anderes
Kunst am Ende des

20. Jahrhunderts
Kunstsammlung Nordrhein-
Westfalen, Düsseldorf / DE
Szenenwechsel XVII
Museum für Moderne Kunst,
Frankfurt am Main / DE

1999 Colour me blind!
Württembergischer
Kunstverein, Stuttgart / DE,
Städtische Ausstellungshalle
am Hawerkamp, Münster /
DE, Dundee Contemporary
Arts, Dundee / UK
Fremdkörper – Fremde
Körper
Deutsches Hygiene Museum
Dresden / DE
Missing Link
Kunstmuseum Bern / CH
Szenenwechsel XVI
Museum für Moderne Kunst,
Frankfurt am Main / DE
De Coraz(ì)ón
Tecla Sala, Barcelona / ES

1998 Das Versprechen der
Fotografie / The Promise
of Photography
Sammlung der DG Bank,
Haramuseum, Tokyo / JP,
Kestner Gesellschaft,
Hannover / DE

1996 Surfing Systems
Kasseler Kunstverein / DE

1992 Surface Tension
The Art Museum, Florida
International University,
Miami / USA

'My tenacity is a place,
not an attitude!'

I would like to thank Jarek
Pawlowski, Richard Cork, Keith
Davey, Graham Southern, Harry
Blain, Pernilla Holmes, Calum
Sutton, Kevin David, Stuart Taylor,
Mark Prime, Deklan Kilfeather,
Karen Garka, Simon Wilson,
Matthias Arndt, Thorsten Tack
& Helmut Hahn, Jörg von
Bruchhausen, Hendrik Driessen,
Christine Traber, Jürgen Geiger,
Madrina Gisela Hamber and most
of all my wonderful wife Ingela,
our children and my parents. AH

Published by Haunch of Venison,
on the occasion of the exhibition,
Anton Henning
Sandpipers, Lizards & History
at Haunch of Venison,
28th April—25th June, 2005

Haunch of Venison,
6 Haunch of Venison Yard,
off Brook Street,
London, W1K 5ES
T +44 (0) 20 7495 5050
F +44 (0) 20 7495 4050
www.haunchofvenison.com

Photography:
Prudence Cuming, 2005
Jörg von Bruchhausen
Works of art ©
Anton Henning & VG Bildkunst,
Bonn / DACS, London, 2005
Publication ©
Haunch of Venison, 2005

Design: Spin, London
www.spin.co.uk
Print: Cambridge University Press

Edition of 1000

ISBN 0-9548307-5-X